A Presence Behind the Lens

Title page symbol: Traditional Chinese calligraphy representing *Chi* or *Qi*,
meaning "life force" or "spirit."

A Presence Behind the Lens

Photography and Reflections by

Nicholas C. Hlobeczy

HOHM PRESS
Prescott, Arizona

Cover design: Kim Johansen
Layout and design: AdMedia, 888-240-2600

Library of Congress Cataloging-in-Publication Data

Hlobeczy, Nicholas.
 A presence behind the lens : photography and reflections by / Nicholas C. Hlobeczy.
 p. cm.
 ISBN-13: 978-1-890772-51-2 (pbk. : alk. paper)
1. Photography—Philosophy. 2. Photography, Artistic. 3. Hlobeczy, Nicholas—Aesthetics. I. Title.
 TR183.H56 2005
 770'.1—dc22
 2005014555

HOHM PRESS
P.O. Box 2501
Prescott, AZ 86302
800-381-2700
http://www.hohmpress.com

This book was printed in the U.S.A. on acid-free paper using soy ink.

09 08 07 06 05 5 4 3 2 1

DEDICATION AND ACKNOWLEDGEMENTS

I dedicate this book to my wife Jean, for her great patience, and to my two children. My daughter Robin helped with the many rewrites, which were needed, and my son Nathan helped by pushing me to make myself even clearer, and insisted on more rewrites.

I would also like to thank all those friends who looked over the manuscript and gave suggestions. They were all kind and encouraging. But in particular, I thank Kevin Langdon; his collaboration in editing was creative, supporting the voice of the author. In fact, our work together was an expression in itself of the very process described in the book. We had lengthy conversations on the phone, checking expression and editing. What a fine learning process this was for both of us. Also, there were David Ulrich and Bill Shumway, and a particular thanks to Thomas Bach, who spent countless hours with me explaining that my work was worthwhile and needed to be published.

In addition I wish to extend a special thanks to Barbara Wright, Richard D. Zakia, Tim Shuckerow, Peter Bunnell, and last but not least Peter Wach my photography dealer who has handled my work for many years.

CONTENTS

Foreword by Richard Zakia .ix

Introduction by Barbara Wright .xi

Author's Preface .xv

Chapter I – The Discovery .1

Chapter II – The Strength of This Light17

 Photos: *I.* *Path 29*

 II. *Difficulty Hill 31*

 III. *Plum Tree 33*

Chapter III – Playing a Part .39

Chapter IV – The Experience Concerning Time's Nature55

Chapter V – Entities . . . When Images Become People69

 Photos: *IV.* *Blood of Christ 79*

 V. *Steps and Reflections 81*

 VI. *Easter Tulips 83*

 VII. *Two Leaves 85*

 VIII. *Island 87*

 IX. *Empty Cup 89*

X. *Transmutations 91*

XI. *Seal Rock 99*

Chapter VI – A Little Personal History .102

Chapter VII – Many Choices . . . Many Joys 118

 Photos: *XII. Egg Lady 125*

 XIII. Two Ladies of Verona 127

 XIV. Blind Musician 129

 XV. "You" 131

 XVI. Dead Cat 133

 XVII. Amish Boys 135

Chapter VIII – Journeys . . . Inner and Outer .146

 Photos: *XVIII. Skull 153*

 XIX. Black Flowers 165

 XX. Eternity 167

Chapter IX – Theater of the Absurd .169

 Photo: *XXI. Meditation Room #2 179*

Chapter X – A Theater of Magic .184

Afterword .199

FOREWORD

If you are a photographer and you want to take your work to the next level, to move it up a notch, this book is for you. As you spend time with it, you will also find your-self moving to another level of awareness and being. The author provides a detailed account of how he put aside his successful photography of people and places in Cleveland, Ohio, in his early years, to journey into the realm of what could rightly be called the contemplative or spiritual. His mentor was the renowned photographer and teacher, Minor White, with whom he studied and photographed. Nicholas credits Minor and others, such as Gurdjieff, for providing direction, insights and inspiration in his search for being through photography.

In his book he has provided us with an intimate and poetic discourse for self-development through thoughtful photography, which at times reads like a diary and at times actually is one. He speaks from a perspective of 78 years and reflects back on some important childhood memories with which we can all identify, revealing how they have served him in his later years. There is an unending search for what role he plays in the creation of photographs and what his photographs signify. After years of intense questioning and searching, he comes to the same realization Minor White did when asking a similar question. Minor, in his introspection, wrote, "When I looked at things for what they are, I was fool enough to persist in my folly and found that each photograph was a mirror of my Self."

The author's search for being emphasizes the need for thoughtful silence, patience and the need to be willing to put in the effort to overcome resistance—to connect and to

be in communion with what it is you are going to photograph. Some might think of this as confluence, "listening to the trees," becoming one with the tree, the rock, the flowers, the landscape, the subject. Others might look upon it as a form of animism in which the object is endowed with a spirit.

Some of the photographs of Aaron Siskind reflect this belief. When he was asked about the meaning of his photographs, he responded, "Pressed for the meaning of these pictures, I should answer obliquely, that they are informed with animism." Capturing the spirit or essence of an object elevates it and the photographer to a new level of awareness and being.

As I look at and quietly study the 21 small photographs the author has included in his book, I sense a connectedness that impels me to silence, solitude and reverence. These intimate black-and-white photographs are surrounded by a generous amount of white space. They have a Zen quality in their presentation as well as their content. They speak a visual language that complements and reinforces what he has written.

Over the years, as a photographer and teacher and in my search for understanding and inspiration, I, like Nicholas, have gathered "straws" from a variety of sources: art, psychology, perception and semiotics. *A Presence Behind the Lens* introduced me to additional "straws" and ideas that have helped me further understand and appreciate not only the photograph, but even more importantly, the meditative process by which the image is created.

– **Richard D. Zakia**, Professor Emeritus, Photography, Rochester Institute of Technology

INTRODUCTION

This is a book of memories, collected together as photographs and vignettes that are loosely autobiographical. Perhaps it could be described as an artful memoir. Without doubt, the book is about art, if what is called art requires awareness of both the environment and the self, along with a certain intelligent skill needed to capture an event or moment. These two requirements are surely met by Nicholas Hlobeczy's *A Presence Behind the Lens*.

Look through the photos in this book. You need to look with care. In the book, there's a quote from William Blake's *The Gates of Paradise*: "The Sun's light when he unfolds it/Depends on the organ that beholds it." If one tries sincerely to look with "the organ that beholds," it becomes quickly apparent that, always, the organ of sight can be more perceptive. The art of seeing requires practice, and photographs—not only taking photographs but also looking at them—offer many opportunities for learning to see. Really look at the photographs in this book. Even the almost unpracticed viewer can see that these photographs are the result of skill. Perhaps the art of making art is not too different from the art of seeing: both require, above all, awareness.

As for the art of the memoir, read the wonderful stories of the author's childhood, his encounters with artist/teacher Minor White, or of his personal struggles to learn and teach others, all of which Nicholas endows with clarity, light, and with "a new looking at what lies before [him]—a thin thread that leads back to the source." Again, awareness at work. Whether he speaks as memoirist or photographer, we are touched by his sincerity and his ability to see, and therefore, by what he can share with us.

Evoking similar feelings in the reader, these stories recall memories or impressions of certain moments, and of what was happening just then, both inside the man and in the world around him. They are records of special moments.

Over many thousands of years, human beings have been keeping track of the events in their lives, trying to hold on to what will always slip away, even as it fades from memory, and while holding on, trying to share these moments with other men and women. Everything, everything, will disappear sooner or later. And yet . . . in this light, art becomes an attempt to pause the flow of life, to make a record of it as it is, stopped, forever unchanging, not dying; and, by some talent or practiced knowledge, or a combination of both, to make that same record not only beautiful, but somehow laden with meaning, the poignant truth that all humans know, even when they forget: this exquisite moment too shall pass. No life without death. Like priests, artists aspire to remind us of this. Beauty only exists just then, in the unchanging moment, and in the truth that lies behind it. Beyond the forms of both religion and art, this truth is forever new, elusive, and mysterious, reminding human beings to search for awareness and meaning, and reminding them to remember, and somehow not forget, that even as it disappears—and it will—life is both indefinable and very precious.

It is this feeling for life that pervades both the photographs and the text of this book. Nicholas places himself in front of many questions, and his longing to understand leads him further, and deeper, into the mystery. Life is indefinable, but we have to try. And life is also very precious. One feels it in the quality of light and form that complement each other in the photographs, or the self-recognition evoked by both his childhood experiences and his adult questions. Listen, as he describes a Chinese practice that seems for him a summation of what is at the center of art, his own life's work,

and this book: "They bound straw tightly to use as fuel for their fires (tinder to be exact). When I discovered this practice I saw that works of art, and my own work, serve as kindling for the fire. The feel for me is that pictures unearthed in the pursuit of truth are the materials that feed and sustain the fire of being human; they kindle the faint embers when they wane and all seems about to turn cold."

Find a good lamp, with good light. This is a book to read on cold evenings. The pictures, whether captured by memory or a camera, will keep you warm, and might also keep you human.

— **Barbara Wright** is an editor and teacher who lives in Toronto, Ontario. She has been an artist and musician, as well as a student of spiritual practices, for many years.

A book about "camera work"

This book is about extraordinary worlds; places in our lives that we can experience. This state we call home—not only the world lived on, but also the body lived in. *A Presence Behind the Lens* contains a symbol of the "something" of my beginnings as an artist, and reveals common traits that can lead us in that direction. Through the book, the strength and insistence that a force (the muse) exerts on us becomes apparent. It is true that not all of us are predisposed to obey that force, but it does actually exist. This someone who exists behind the lens of the eye, and the camera lens in my case, seems to be presence itself, a force held in the heart and mind, and together they are woven into a tapestry that reveals much about the origins of my own humanity. I am speaking of my childhood and an awakening sense of self. I address inspiration as the very breath of life, and resistance as a force that compels me to move into action; these traits that lead to self-realization—how we evolve. Through examples drawn from my own life, I hope to show this evolution of some quite exciting ideas and possibilities. For me these ideas are like a string of pearls that lead back to the very nature of life itself.

I include experiences with poetry, painting, and especially photography and the struggle for Self-expression. I have also presented many discoveries about trying to teach— insights not often spoken of that I have gathered from years of teaching photography.

———

Is art a vehicle? Then where does it carry us? I have the strong notion that art carries us another step in our evolution. It need not deplete the human store but rather enriches it.

I realize that there is a lot of art in the world that seems to take things down, or tear apart any sense of humanity. But is the fault in the messenger or the message? In the viewer or that which is viewed?

There is a call to become a student rather than be a teacher, to encourage through example, and to embrace and accept questioning as a way of life—a true exploration of what is needed to search for freedom.

Presented in the book are photographs and poems of mine and also many examples of the well-known writings of others that correspond with my own views. Among other sources and influences, I harken back to Robert Henri's book, *The Art Spirit*, reminding us of the importance of the individual in any community.

———

There appears to be a fundamental flaw in the practice that Socrates called "the examined life" which brings a realization—that we are quite limited in our capacity to understand one another. I see this is true concerning my own capacity to extend feeling toward another. Understanding is certainly hampered in this way. I do attempt to overcome this shortcoming, and at times I am able. It seems important to try, and I am pleased when I am able. In this experience is a realization: that we are equal and, taking it further, a knowing that we are one. All this can be found through the pursuit

of art. It can enable us to realize our humanness. Even so, relating to each other in life does seem dangerous. The interesting thing to me is that some people in the arts become better at relating to others, not only as actors from the stage, but also in every-day life. Does a right practice exist? Perhaps. The inclination to experience self and to pursue understanding is a seed planted deep within us. I am drawn to this idea like iron filings to a magnet; I may even be called to this.

———

Having been absent from cognizance, perhaps for decades, I have come to something I did not quite comprehend earlier. In passing through the bottom of this pit—of despondency—I have come out the other side feeling more myself. You may know the feeling, a kind of letting go and allowing truth to enter. It brings me with it—the real me—not some imaginary frightened idiot. To me being unconscious of life is like being in a deep pit, experiencing no sense, without tools to express myself. Where others did not see the *seer* within and misunderstood, I was able, with luck, to understand; therefore, great value came from being friend and student to that *seer*. The manner in which I came to understand the *seer* and what he taught me is as follows: Something is always changing in us—it has always been so, but only shows itself fleetingly. To understand the truth given us, it needs to be seen in the fleeting moment we call "now." It's not what we think is happening; it is realization itself. The "now" is a return to a kind of clarity—where no words actually suffice, it heals and makes existence possible. The clean clarity of self in the moment of creativity has no specific place where it abides. It is all-encompassing, and is within everything. All teachings I have experienced pale in its presence. The visions received in this experience seem to come as a gift out of the very air that surrounds us.

There is a need to impress upon myself these new findings through practice and staying with them longer and more often. An even more important reason is that I seem more myself in this experiencing—and so I sit, reason, write, and remain open to all about me, not lost in any one thing, though many things pull at me: feelings about ideas, about my health, or the uncomfortable chair upon which I sit. All tug at me, reminding me that there is again need to find the silence that has left with the advent of these innocent realities. Looking at it simply, it becomes apparent that all these distractions are innocent of any wrongdoing. They are just distractions of an unoccupied mind that can become reminders.

It is clarity I am speaking of, and it begins with a sense of clear concentration in which unerring silence is present. As I think, I also wish to maintain cognizance of this silence. It seems both needs exist. At times concentration with silence makes a thought clearer—enabling a connection. I work even though there are many noises around me, like the music on my computer. Somehow the sound can help me maintain awareness of silence. I flicker back and forth between these impressions and at times they coexist. These impressions are all in need of a caretaker; I do not realize that most of the time. For most of my life I didn't even understand there was this possibility.

I wish to put a good turn on the things I have learned. It seems learning is a cleansing process, one the artist must experience. Some artists say it is like undressing in public to produce art. I feel that it is not that the artist bares himself in order that others see him, but rather that he sees and therefore this bares us all. I am drawn to this feat, sensing the trueness of that effort. I become that, and for a moment there is a sense of freedom. Artfulness, to me, indicates inclusion of all that can be brought intentionally. We experience the result consciously or unconsciously, and are seldom aware that,

for better or worse, we have been changed. All is improved, however, when we discover that we are able to watch the process as it takes place.

In my mind are many memories; some are true and there are those that are false. My life is governed by these memories. Within is a shape and form that has determined who I am. Nevertheless, I see that there is a growing clarity of another, a contrary purpose. This new purpose seems to come through art. The purpose is not easy to grasp and certainly seems beyond words to communicate, but I will try. In any event, I now find myself making the attempt.

This is in fact what my book is all about. It is what people refer to as *raison d'être*.

———

Chapter I

THE DISCOVERY

I find myself here

I was asked to put down my ideas about experiences and feelings in photography. This will be difficult for me because I am not a writer. I am a photographer with some experience in writing essays, and I have written a few poems. How it moves will depend on a few things. In particular is this feeling that there is a need to experience inspiration—a kind of impulse from within. This impulse seems to have a force that drives me on. It has been true of all the creative fields I have worked in. This project will be a view of my situation of the moment in photography, and in this writing as well.

There seems to be a materiality to inspiration—in the experiencing of it, or perhaps better said: it demands—of me—a certain materiality. It is daunting. How else can ideas push me into action unless they have a materiality all their own? So I feel a push

from within, but why? I don't quite understand. It is perhaps suspicious, and ego no doubt plays its part. One step taken demands another follow, and perhaps this is not ego, but simply the need to stay upright, and to be as clear as possible. No ambition is actually involved in the ordinary sense. I have to keep up and stay on track. When I fall from grace, I'm sure you'll notice. I wish not to fall that far.

For me it does not necessarily follow that I am already human just because I'm here, and am a two-legged animal. I am not all that sure that being human comes with the territory, nor without work. To go beyond my talents is my wish—in order to expand. That attitude helps make me potentially human. A capability is felt; a potentiality for being more human can be sensed. This would even be more desirable for me than being a photographer, or a poet. It may even be that in crafts we have a tool for developing this trait of being human. It relates in some way to bringing myself into balance. For every push there is a pull, resistance at each turn, and, in between, a truth. No compromise here—at least this is what I experience. Returning to this realization often is most important, and in the mix there is a chance of remembering that it is my humanness I wish to be in touch with—to express.

This wish cannot be hatched by dreams. There are form and reason to be considered. It must be nourished through sustained intent. But what do I actually know about intention? Is it possible to even be sincere? Just because I walk upright is no reason to consider myself better than other creatures. Even these creatures show some development, but for those like myself something more is possible. There could be something more in being human through the experiencing of art. I would like to speak about these things. I hope to make it possible for you to come along with me.

When I was young, I had a calling to express myself and considered myself to be an artist. Now that I am older, there are many questions. It is true that I have managed to make some strong photographs, and in this way I have felt called to search more deeply. Inspiration comes to the ill prepared as well as the well prepared, and lately there has arrived for me this additional struggle—to write. It is wonderful and exciting, like the time when I was learning photography, with all its problems and frustrations. For reasons not fully understood, I appear to have been taken by this task of writing, as I was—and am—by photography. All art is about being enabled by that which is higher in us—at whatever level of balance we find ourselves—and about the turbulent waters we cross to receive such gifts.

Some people say art is about healing. My experience is not that art heals us but that art is what is revealed through this creative journey. At the same time, we cannot come to art with empty hands. All does not exist for me simply to dabble in. The whole effort needs to include a skill of mind and body and a willing heart to engage truly. Rather than come to a conclusion, it would be better to think of the process and potential results as a mystery, which brings a breath that develops my being. Learning about this is my wish.

Though art does reveal, and makes known what is seen, it does not always bring regeneration. There is something additional needed—understanding. There can be confusion on this point when I hold what I have seen too closely to the vest, not sharing. In that circumstance, understanding cannot grow. It may well turn into a virus that can harm me, and those near me. Not sharing is the very Devil. There can be a receptive moment when we are able to share. Any attempt to appear better than my peers often involves a silence on my part that can be taken as a knowing. It seems to me that there

is a magic and truth that can be brought into the world when we speak out, though it is at great risk. In anyone's ill-considered actions can be danger. With this in mind, my intent is to write about the photographer in me. An ordinary sense of "me" brings a second character in. There are these two, but additionally, during my growing up, I saw that there is a third entity. This presence inside is so filled with light and life. I am compelled to write about that being as well. I believe it is from this third being that all good and worth originates, but its purpose cannot be carried out without some kind of new balance within. Writing about this third part is skating on thin ice and grave danger lurks in including it, but I must.

Much was simpler when I was learning as a young man. In photography, directions were found on the box for the contents within. The only place I had to look for help then was to follow that yellow box, "the yellow brick road." (Eastman Kodak boxes were always yellow.) Everyone understood this expression in those days. Just as today people say, "Read the directions, dummy." In working with computers we have such helps as *Windows for Dummies* and similar works. It may not be too different in writing, as there also are books on writing. The important things I bring to the task are inspiration, former training, and myself. How and what is done with them is up to me. There are many difficulties in expression. I am fortunate to have the time and the capacity to address these troubles; I may even have the skill.

———

Some parallels with another craft . . . and other reasonings of the heart

Rainer Maria Rilke writes:

Silent friend of many distances, feel
How your breath enlarges all of space.
Let your presence ring out like a bell
into the night. What feeds upon your face

grows mightily from the nourishment thus offered.
Move through transformation, out and in.
What is the deepest loss that you have suffered?
If drinking is bitter, change yourself to wine.

In this immeasurable darkness, be the power
that rounds your senses in their ring,
the sense of their mysterious encounter.

And if the earthly no longer know your name,
whisper to the silent earth: I'm flowing.
To the flashing water say: I am.[1]

Life is a taste that needs to be cultivated. This cultivation cannot take place without
intent on my part. I wish—strive—to be a student as I engage in my work. Through

this a taste of life can begin to appear. The wish is in me, but I need to work to find it. It is not easily found. It is not experienced as desire, and it does not arrive like the sun, the rain, or the wind, which come through the mechanics of nature. With this wish we can become apprentices at any age. It is necessary to again become students. Here we can meet a sense of awe—a sense of joy, even fear. All these parts breathe together, and in this way discoveries arrive. Many things can unfold.

Numerous points of departure are available in art. What lies beyond methods might take us further. To seriously look at questions helps. In following my interest I discover that I have not arrived here to do what has already been done, but to make my own road. So writing inspires me and brings the courage to stand up. I wish to convey more than the technique of photography.

Photography—as all art forms—reflects its practitioners. In each person can be found unique expression. Artwork done from borrowed experience would be a worthless waste of time. That would be in opposition to the reality of an individual's natural worth. Most of my life has been illusion. I have lived long enough to reflect well on this fact. There have been few moments that have had the taste and intensity of a fully balanced experiencing, unfettered by the dreams of time. I have seen my foolishness in following the influences of others. My knowledge is not flawless, but what I do know is mine through experience—hard fought and paid for. This brings strength and enables me to find what is true. To see this requires me to be honest and to see my poverty as well. It becomes obvious that copying the photography of another is an empty game. There is something that works in secret for the growth of my own being. There are impressions that are available, which could find expression through me. There is a note I need to write to myself as a reminder: Am I here to trace lines, shapes,

and tones already made? It takes strength to be on my own—searching. What do I support and what supports me?

There are times when it's good to be cautious; this may be such a time for you, the reader. In teaching I have been guided by a principle that I am not in this world to teach what I know—we cannot actually. So I attempt to excite students into learning what is already known within them. This allows their essential nature to speak out. There is, of course, a truth that when stepping-stones are available it makes sense to use them. At issue is the ability to proceed, rather than move in the interests of accident, or imitation—not to vacillate. So I have a few tricks to share.

———

Hopefully, I, as presented in these pages, can be a mirror for others to look into—even a door through which to enter into a new life. We all have work to pursue. The trouble is in finding it. Then one must stand up for it once it has been found.

———

Obstacles urge me to make efforts

There are issues in talking about creativity. If you speak to others about such subtle subjects, then you need to speak about all that makes it possible. Resistance is certainly an important aspect to speak of. I talk about resistance to indicate how we can weave a different fabric out of resistance—to somehow use that resistance as a measure, and to arrive at something affirmative. In fact, if you do take an affirmative action,

resistance is not far behind. It becomes a means of locomotion. Of course, people don't want to hear that. It is thought that all art is beauty and that it happens like breathing. Still, I don't know how you can explain art without sincere questioning, without noticing the movement of things, but resistance is also a necessary and natural part of it all. People want the experience but at the same time they're reluctant to go beyond their usual boundaries. What can be done is to be an example, which is what I have tried to do. Not all will recognize the example or find value in it, but one can only make the attempt to communicate.

I expressed some obstacles I had in writing about creativity in this note to a former student:

Birthday Impression, 9/9/99

I am the clapper; you are the bell: when the bell is struck the resultant sound can be clear and sonorous. You have said clearly what I need to hear, that I need to know to whom I speak. It is the same no matter where we go in the world; I need to be a proper clapper and the bell needs to be of the right stuff to resonate. There is a need to know how to include both; it requires a sure openness. To arrange this possibility takes real craftsmen, sensitive persons with vision. None quite lives up to the mark but together there seems to be some chance.

Each of us can make sounds. It may even become music. But in everyday life there are creators of dumb, dissonant noise as well. The possibility of tuning responses to one another nevertheless does exist. It comes out of

learning to listen, simply being what I can be—an observer, not changing what I hear. We might respond to the clapper, or be the clapper. We may never hear the music of the spheres. In the end an artist needs an audience and the artist needs to know what the audience will respond to.

———

A new freshness arrived in me today though it is quite dark outside; in fact there is darkness all about me. There is a spark of something astonishing within—why not? I am just giving attention to the moment. The sense of a thing—its worth—is what human beings will lay down their lives for. Some say, "On which people wager away their lives." Do they? It may be quite true; here is a question not to be answered too lightly. We need to hang on to questioning our beliefs. Keep them open; new discoveries may arrive. So, I am just enjoying my moment. No risk involved for me because even if all goes wrong I will survive.

I don't know about man as a whole; it's honest to say that. I still behave as though I know myself! It seems rather an accident about to happen or that has already happened. There's not much here by intention, or conscience, in saying, "But don't you see I am acting by my own volition?" It is sad. Who, then, is trustworthy in the objective sense? Is everything based on need, or avarice and appetite? No reason to respond. The word "need" seems too abstract. In any event, you are precise in thinking there must be a new direction by searching for a new basis. The fact that we see our weaknesses shows that we can go beyond. The worst conditions may be the best for my

work now. I keep my eyes open because the real problem is that I don't know how thin the ice is. New beginnings are essential and I will keep at it.

As to the opening statement of my book, I must learn to make myself clear. There is a somnambulist "I" in me; and there is a photographer not as asleep as that sleeper. The craftsman knows how to search for image *(photographs that have meaning), while being secretly in contact with another, more hidden, entity inside—this secret sense of presence behind the lens of the camera and my own eyes. This personage who plays hide and seek with me—he is never far off. This can be realized only through working. Such a presence is much more aware and conscious than the craftsman, or me. Could it be that I have made this more confusing than it need be? For now it remains a mystery to me. The joy will be the pursuit. As for God—I know nothing. I simply enjoy what little consciousness I'm given and am grateful for that.*

What I saw when I wrote the note to my friend was that we all realize the great value of seeing questions. Moreover, the seeing and looking includes seeing myself. With this attitude much good can come, and a result which is honorable. The idea of questions that give birth to genuine questioning began a long time ago with my first photography teacher, Minor White, and his own peculiar inclination to question everything. Without resistance and questioning, the *image* on the ground glass is virtually meaningless—empty and hollow.

———

The Chinese sage Lao-Tzu is reported to have said, "The larger the island of knowledge, the longer the shoreline of wonder." Albert Einstein had astute insight as well in stating, "The experiencing of the mysterious is the source of all true science," and I would add: all humans when searching in wonder and awe can find wisdom—that possibility lies in all the arts—but without self-knowledge all is empty. Another observation attributed to Einstein is "Genius has its limits but stupidity is endless." So care needs to be taken for sure.

This book is linked with a practice of the Chinese. They bound straw tightly to use as fuel for their fires (tinder to be exact). When I discovered this practice I saw that works of art, and my own work, serve as kindling for the fire. The feel for me is that pictures unearthed in the pursuit of truth are the materials that feed and sustain the fire of being human; they kindle the faint embers when they wane and all seems about to turn cold.

All this was not true about my work when I began. Much was caught up in possession, pride and self-conceit, where no freedom could be found, let alone kindling. Over the years this has passed into remission, and now the *images* are more often a sacrifice given for the growth of being human—toward connection with a greater energy source that lies within. My intent is that practical evidence might be found in *A Presence Behind the Lens*. It may even be kindling for the fire of others.

———

You may wonder why I am writing so much about learning to write rather than going directly to the photography. I do so to show that you may have some of these same

problems in learning photography. I would like you to see that if I am able to have some success, you might find your way as well in photography—it's staying power that counts. I am writing about resistance encountered no matter what art form we may choose—that resistance is common to all. It is my resistance that measures my ability. My approach to photography is not conventional. It has been a long and twisting trail, and I am fairly adjusted in my present role. There are many and varied experiences that add a sense of rightness to my current work. Still there are many uncertainties strongly rooted in experiences of childhood. It is connected quite strongly with my art, so I will tell some stories.

Many years ago I was a child—living on a hill in a small town in western Pennsylvania. There was an abandoned stone quarry that existed in those days on the outskirts of town. It was filled with spring water and was called Rock Bottom. In fact it was in a small valley behind my house; now only the house still exists. It was the local swimming hole for all, both near and far. Most of the boys in the neighborhood hung their bathing suits on a willow tree in my backyard, because they were not allowed to swim at the quarry. They wanted to keep this secret from their parents. My mom and dad evidently felt I was responsible and a good swimmer, so I was not prohibited this luxury.

My street was at the edge of town and we ran the hills like wild colts. We, like most young people, were impatient for the day when the weather would turn warm enough to go swimming. One spring Saturday we were running and raising general hell on the side of the hill when all together we came to the same notion—let's go see Rock Bottom! It was a beautiful

day with clear, wonderful sky, unusually bright for this time of year, so off we went screaming down the hill. It was quite a ruckus. When we arrived, the great body of water temptingly mesmerized us—lying quietly with steam wafting from her surface. We all stood in awe, hypnotized and silent.

An argument arose as to whether the water was warm enough to go in; one of the kids finally stuck his hand in to the wrist at the shoreline and said, "A little cool but should be fine." Some of us were a bit dubious, but I was open to going in. Someone said, "Last one in is a so-and-so." So off came our clothes in a great jumble, with each trying to be first. For some odd reason, I was first (that had never happened before). I ran to the low board with full heart and dove in.

I was in shock and all but blacked out. The wind was knocked out of me as I plunged deep—deep into the ice-cold spring water. Turning in the water, clawing at it with all my might—time was moving in slow motion—I regained the surface with great gasping. Grappling at the rocks, I dragged myself up and out as though burdened with great weights. All my buddies were standing there dressed, laughing at me. I had been betrayed. Dressing silently, I thought, We can only see our trust gone when it's taken from us.

A few of my friends today are just such tricksters as children are, which is not of concern and may be very helpful—now that I understand a few things better. This is the nature of my dilemma: I am capable yet skeptical. I am hoping not to fret too much on this account, and I do feel reasonably sure of surviving, even though it may be that

I have been maneuvered into writing this book. This time, will I see myself basted and broiled rather than frozen in ice-cold quarry water?

————

In another note written to someone who had read an early draft of my work, I find again a note of caution.

The note:

I appreciate your response. Glad you got so much from it. There is a thought I have that the reader may want more from me than I can give, or something completely different. Who can be sure that what is written is complete? What I rather hoped for is that the reader's own fires would begin smoldering and would need tending. That would require attention. Attention is the reason behind all that I do well, so why should it not serve them?

There is a dream I will share with you. It is very related to a story I used to talk about with students in class—about a conduit or stream that flows through photographic history and that many wish to be part of—to help carry that further. Not everyone can be a part of that conduit but there is a need to see if I can do so while not deceiving myself. It is important not to follow false notions of myself.

So your response has triggered something exciting, and at the same time there appears a sense of grave danger. It's like seeing the grave digger

walking across the turf with shovel already in hand to bury me. So maybe I won't find a publisher; I'll make a few copies for myself, and friends who have a taste for it.

―――――

The dream:

I was walking in one of those city parks that are often found in rather desperate neighborhoods. In walking along I found a stream—a rather large stream, which was crystal clear and had a reflective surface. In following it for some distance, I saw under this glaring surface many dismembered pipes laying rather haphazardly. All were more or less running the length of the flowing stream. In zigzags they each carried the stream forward to its destination, though somewhat confusedly.

The stream seemed not to need the pipes at all. I tried to get to the source of that logic—to some intelligence. I hoped to arrive somewhere in the dream. I did not go with the flow but walked against everything upstream. It was a tough neighborhood and I was aware of feeling that everything was in the way, which at another time would have held me back. In this dream, though, I felt strong and confident.

The dream suddenly ended!

It's like that. I wish to carry this sacred water to its destination. I even feel I can, but something is missing so often in my observation. I know the goodness of a thing, but am usually indirectly connected to the source. I am not connected in a firm way. This may be the point. Yes, I may carry the waters of life, but for the most part I am oblivious and disconnected in any useful way from this source. Am I one of those disconnected pipes—enjoying the flow through me? Or could I be connected in a better way with the source? Here are the possibilities. I may never find the source or all the connections, but I continue to look, and the search itself is very exciting. This does not mean I have found something as yet. One has to be very careful not to make bold assumptions.

———

Both letters and the childhood stories are examples of how insecure I can get about venturing forth, but I must express them or burst. It seems that in reaching out to others—to past experience as well—that time and again I am looking to be comforted. In truth that is not what I am doing, at least in my better moments, as courage does not come from that action. It comes from deep in my inner world, and is born of the moment—in a flash strength is felt. It is what is needed to meet resistance. A sense of presence seems at times to be watching my actions. It is the best of all measures. This can be explored, along with its relationship to my craft of photography and the why of everything that gets in the way. At the same time, it can be encouraging to have a sounding board in others.

Endnotes, Chapter I.

1. Rainer Maria Rilke, "Sonnet XXIX," in *The Sonnets of Orpheus*, trans. Stephen Mitchell (New York: Simon & Schuster, 1986), 129.

THE STRENGTH OF THIS LIGHT

About wakening to a sense of being

It appears I may have been interested in philosophy all my life, but the why and where-fore of it is hard to find in my upbringing, as I was not trained in philosophy. Since then I have searched and have found much that has encouraged me to find more facts about the roots of my inclination to be a photographer. In a sense, I am quite primitive in my belief system. In me there is madness and very little method, yet I do search for order—for ideas.

The element of light or fire seems to be at the hub of everything for me, and from there I have managed to proceed—as a photographer. This is the point around which all my thought and actions have revolved. Light makes known what otherwise hides in the shadow land, or in darker places.

From my notebook:

I awoke from a deep sleep. A word came to me with this awakening—it was "quintessence," a fifth element. So, fire, water, earth, air and—this fifth thing, quintessence, *that I refer to as the* seer—*it is for me the fifth! My dark world has brightened with thought and photography often. Imagine— all that exists comes out of night. This great silence flows filled with mystery.*

This was not my first contact with this word and what it signifies. The first was about ten years earlier, at a gathering of friends. The word quintessence came up in a discussion at the time; I could not remember the word a moment later. There was confusion about the relationship between quintessence *and* seer *in my subconscious at the time, but not now.*

In a small meeting of people interested in such questions, a wise friend, Michel de Salzmann, said, "This quintessential mind and this very necessary body . . . how to make a connection, establish a relationship? Is it necessary?" We went on quite some time talking about this question. This thought of the "quintessential mind" confused me, and in my desire to grasp it, I soon lost this very alive question. For the life of me I was not able to remember the word quintessential, *let alone "quintessential mind," or its significance. Now as I write I realize a new connection. It is true that without being here seeing, meaning could not exist.*

After that meeting I was lost, still chewing on the question. I saw Michel walking outdoors and asked him if he remembered how he had put the

question about the mind and the body. He looked most puzzled and innocently said, "I don't know. I will try to remember." We paused for a moment, being very still, and after what seemed a few seconds he smiled, then turned and walked away. I was left in question; where was this thought? Still overly emotional and determined, I struggled to unearth it. It was only when I returned home that the word arrived, without any pushing or grasping on my part. My experience shows how desire keeps at bay the very things I am looking for. It is the same in photography when I try to force things.

———

Not only a relationship to light but to the state of enlightenment itself

The experience of seeing can be a rare moment. The photographer Edward Weston called this moment "the flame of recognition," Ansel Adams expressed it as "the eloquent light," and Henri Cartier-Bresson referred to it as "the decisive moment." Minor White puts more flesh on it: "The light is seen to illuminate with holy indifference." He also speaks of the various qualities of light—its ability to heal, to make love, to kill, even to regenerate, and maintains that images can change our state of mind. He also speaks of a search for fidelity to the "I am Self." In this Minor seems to champion the idea of *camera work*, as Stieglitz may have intended. Originally when Stieglitz published *Camera Work*, an independent quarterly, it was based on ideals and principles. His concern was that the artist's work be built on a faithful rendering of deepest experience—an expression of the sacred and wondrous—and this he termed "camera work." It is more than a job or a craft used to make a living; it is a tool with which to craft my life.

It is not just the light of seeing something. It is a special moment when the sight of something and the sense of "me" are experienced as a unity. It has been put many ways. The photographers above speak of "the light." I presume they include themselves in their experience, as Minor White does.

When it comes to actual practice in craft, there are many obstacles. Often we leave out ourselves. There cannot be truth in expression unless a part of this light is realized to be part of me. I don't always experience this, but I have tasted it. The art of seeing depends on knowing this taste. Without resonance in the body there is imagining without end, keeping me away from the real point of work. My own way of expressing it has become, "Let the light of the subject speak for itself, and allow it to resonate with the light within." To be more connected with my inner and outer world, a search for that lost natural sense, could be an aim—and a reason for making images.

It is not the ordinary things I think about a subject—those associations that grind away in me—this is not what sustains and encourages my search. It is what I sense about the subject throughout my body: Sensing the straightness of a tree or that it is crooked. Sensing the distances from and between things—in a way, it could be said, "their conversations." What is the quality of coolness or heat upon their faces and upon my face? All these things bring fresh seeing—a clear perception—unfettered by ordinary balances and measuring.

In sensing the subject directly, I begin to include more completely what is before me. In order to go on, the element of feeling must be added through a work of intention. Without all these qualities there is incompleteness—subtle disconnections that add up to large misunderstandings.

A new mind needs to be in our work, a mind that brings new impressions gleaned through presence in the moment, when one is not caught up in associative thinking. With this sensibility there are uncommon impressions—and a new insight. This is so because the body lives in the present—in the greater reality of now. All too often I am led down the path of traditional conceptions and immersed in the familiar—that flat-land of the habitual. Familiarity leads me no particular place other than into rationalization and wrong effort. Most useful impressions escape recognition because of closely held notions, or misplaced ideals.

The measure of art is a measure of the person—a measure of the level of one's place. To work with art is the same as working hand in hand with spirit. In our experiencing there is no concern for making perfect, but only for allowing the *seer* to see and do its work. It is not essential to be concerned and overwhelmed with making money through art, because you won't. The real value lies elsewhere; art is an expression of spirit, and my effort is to keep alive that quest. It seems only time can resolve the question of money, so let it rest while working with art.

———

A way of looking at craft

It is odd but true that we attempt to use the image when what actually happens is that, unbeknownst to us, we are used by these pictures we take. We are led astray quite easily and are caught up quite unintentionally. There is a certain value, however, in making photographs intentionally. Making photographs is worthwhile when one is vigilant,

recognizing that it can be an ego-building game, in spite of my intent. Those kinds of pictures can be a product of automatic presumption. One can only concentrate through intentional efforts to remain present—not lose oneself in it, or dream. Images have a value. They are very important when used as a conduit to carry me back to the present moment. There is an energy that enables me to move from *now* till *now*. When this energy is available, images become stepping-stones to self-observation. It is this process that takes me away from my ordinary mind and its dreams. The past and the future have a different relationship with this movement. It is, as has been said by many people, revolutionary.

Through craft, humans are enabled to experience vibrancy. From this more vivid state things are observed cleanly, without imposition. We are able to see outwardly and inwardly with great clarity. It's like a light turned on. Seeing my inner content enables me to see the world as it actually is and has always been without my noticing.

———

How others have helped me include the muse

At harmony with my views is Robert Henri, a good and great teacher and a man of subtle feeling. Here is what he had to say in the early part of the twentieth century:

> The object of painting a picture [or taking a photograph] is not to
> make a picture, however unreasonable this may sound. The picture, if
> a picture results, is a by-product and may be useful, valuable, interest-
> ing as a sign of what has passed. The object, which is back of every true

work of art, is the attainment of the state of being, a state of high functioning, a more than ordinary moment of existence. In such moments activity—inevitable, and whether this activity is with brush, pen, chisel, or tongue, its results are but a by-product of a state, a trace, the footprint of the state.

The results however crude, become dear to the artist who made them because they are records of states of being which he has enjoyed and which he would regain. They are likewise interesting to others because they are to some extent readable and reveal the possibilities of greater existence. A picture is a by-product of such states as it is in the nature of man to desire.[1]

Seeing myself as I go along the way does help, and I suggest you also try this. It gives a measure, a focus for your aim. So bring your natural experiences and look again at Robert Henri's words above. His words could be of help.

Here is my own offering:

And Now—1984

Burdened clouds, sedate in their movement—
low chilled hugging earth.
A Sun blocking sunscreen,
mind and landscape—wherein thought is stilled.

Where in this balance is the needed tempering
for an aspirant heart?
Where the poise, the quiet perception
to envelop all these movements—and yet I wait?
Still and being stilled,
I am silenced.
Through this comes a finer sound,
a music that makes new, and heals.
Here, a crucible of creation within my fleshy stuff,
wherein nature is recharged.[2]

———

It is heartening when poets and writers speak about their experiences of spirit, this magnificence that brings life:

From *Straw for the Fire,* by Theodore Roethke

My bones whisper to my blood; my sleep deceives me.
This motion is larger than air; wider than water;
Fly, fly, spirit. A strange shape nestles in my nerves.
Whisper back to me, wit. I'm ready to be alive.

. . .

What dies before me is myself alone:
What lives again? Only a small man of straw—
Yet straw can feed a fire to melt down stone.[3]

We are in large part a mystery. In each of us there is that which awakens us. It is not expressed the same in everyone. Poets seem to give great emphasis to the idea of a "muse" within, and ascribe all their power—when it is present—to this entity. My heart is taken up in flight with the poems of Theodore Roethke, which communicate with heart what he experiences. For him it may be true and well-grounded, but for most people—myself included—it is easy to fly away with these words. This taste in his poems goes a long way toward awakening a yearning for something finer and more loving than what is normally found. However, there is a need to include the sense of being well-grounded.

When poets use the word "muse," I understand this in the sense of "spirit," or perhaps even "seer." Real art, in any event, is that which meditates or ponders within us. There is a greater reality that can animate us. This can express itself through music, word, or image and with material objects as well; it always brings with it action, movement—and, above all, life—into the world.

Man and animal—we are all equally ensnared in the net of time; from here there is only one place to go, and that would be to return to the sea of eternity. Passing through time is indeed a harrowing experience to creatures from that sea. But what of this ordinary time I have? I use it—by means of art—to remember the goodness of eternity and gather the fruits of time. There seems not to be much success, but then I discover consciousness, and this grows. Out of my effort I am enabled to see the only value in this time shared with each other, and the wish to remember where I came from. It all seems a confusing juggernaut, so I need to continue working. It is not possible to figure things out for the whole world, but there is a chance of untangling them for myself. This appears more promising than trying to save the world, and through

this attitude, eventually there may even be a real value to time. This would bring a true emotional side to the world.

———

From *Letters to a Young Poet*, by Rainer Maria Rilke

Works of art are of an infinite solitude, and no means of approach is so useless as criticism. Only love can touch and hold them and be fair to them—Always trust yourself and your own feeling, as opposed to argumentations, discussions, or introductions of that sort; if it turns out that you are wrong, then the natural growth of your inner life will eventually guide you to other insights. Allow your judgments their own silent, undisturbed development, which, like all progress, must come from deep within and cannot be forced or hastened. Everything is gestation and then birthing. To let each impression and each embryo of a feeling come to completion, entirely in itself, in the dark, in the answerable, the unconscious, beyond the reach of one's own understanding, and with deep humility and patience to wait for the hour when a new clarity is born: this alone is what it means to live as an artist: in understanding as in creating.

In this there is no measure of time. A year doesn't matter, and ten years are nothing. Being an artist means: not numbering and counting, but ripening like a tree, which doesn't force its sap, and stands confidently in the storms of spring, not afraid that afterward summer may not

come. It does come. But it comes only to those who are patient, who are there as if eternity lay before them, so unconcernedly silent and vast. I learn this every day of my life; learn it with pain I am grateful for: patience is everything. *4*

In reading this I awake to a wish to be "enabled"—to be. Spring does come, in a metaphorical sense, and I may by my own struggle be able to awaken some young student to this possible friendship that lies within. A ripening factor that comes with quiet patience is always present, but not often perceived. The search for self-expression through my craft needs to become more vivid.

––––––

Encounters with destiny and a stretching of the feelings

When Minor White began working at M.I.T. in 1965, I was not able to visit him often, but I did visit him that fall. We took a trip up the coast to Maine and I saw Safe Harbor State Park, near Schoodic Point, for the first time. It was a real treat and exciting—I was thirty-nine at the time.

On our way back to Boston from Safe Harbor, we had lobster for dinner—a first for me—accompanied by our own bottle of brandy brought in from the Volkswagen Bus. It was quite a feast; so the body as well as the spirit was fed.

The point of the story is that we photographed at Safe Harbor, and there, within a rather short time, three fine pictures appeared. I only discovered their significance, as

often happens, many years later. All I knew at the time was to hang on to these negatives. The pictures were "Path," "Difficulty Hill," and "Plum Tree." All three address the understanding that in the beginning there was being—that being may potentially be master of my work, rather than ego. The sense of order found here—followed with intent—does lead to balance, and to the release of this imprisoned being. In a special way, these photographs act as a small sequence or "dream" about this search, and the seer's quest to be a part of us.

By the word "dream," I mean dream in the sense that the aborigines of Australia may have experienced it, when they speak of their own dream walk. It is my understanding that they accept their responsibility and place in life through taking this walk into the outback alone, and fending for themselves. Here they are forced to face life and death with their own personal resources. The pictures they draw on cliff faces mark their passage. This was their record of having been there, and a remembrance of their initiation.

The Safe Harbor photographs, which feed my questioning, are a gift, enabling me to connect with my responsibility, and are given in an instant. They are mine to cherish and work with and ought not be considered as "public images" at all. Perhaps in time they may become public. They are a work in progress, and herald a willingness to become an adult—whatever that might entail. They also can become a mark on the wall that will bear witness to my life.

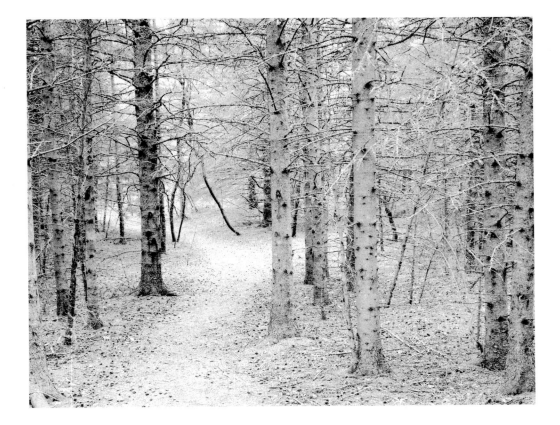

I - Path - Safe Harbor, Maine - 1965

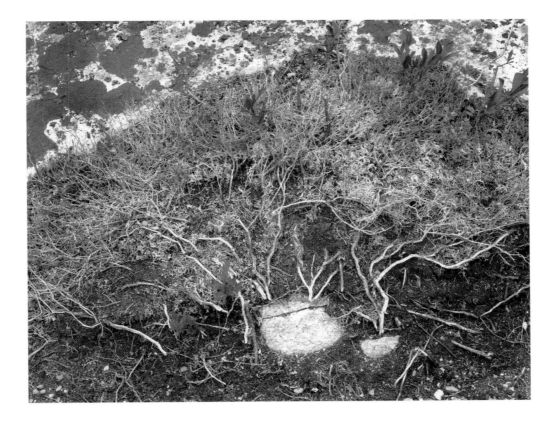

II - Difficulty Hill - Safe Harbor, Maine - 1966

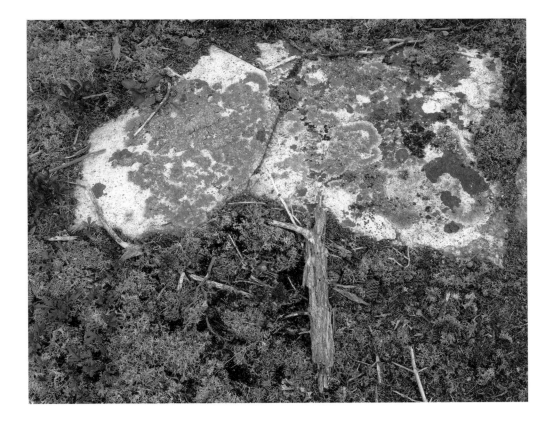

III - Plum Tree - Safe Harbor, Maine - 1965

It was near Schoodic Point and Safe Harbor that Minor found some of the images for his *Sequence 1968*. That year he spoke to me of the ominous feelings he was having about death, and the sequence reflects that. Life and death seem so close together at times. "Ocean," from that sequence, seems to reflect this. What is a beginning for one man may be near the end for another.

Later, Minor gave me a series of contacts from this sequence.

———

When I was young the flame burned strongly and had its way with me; development of my possibilities was neglected in that way. Then there were the passions of the flesh, and the high-spirited, rowdy companions that I chose who also had their way with me. The desire to be in command, no matter the cost, allowed all manner of excuses and trickery. With all this there was a false sense of what life and creation were—impatience run amok. Then, later in life, when success was not achieved, there arose a bitter resentment toward those who seemed lucky to have found some key. In this fashion, new distractions came on the scene and, with them, lying to myself that lulled me even deeper into sleep. But something fortunately did awaken the sleeper in spite of all. I have been helped through great writers and poets and the prodding of a few good guides. All this nudging and encouragement brought me to try sharing my experience. I may not know a great deal, but I do have a respect for that special quality within that I have awakened to. It was not damaged by my rowdy independence, and may even be quietly intact.

My feelings were stretched beyond words as I watched a film about Mahler. He is by far my favorite composer. Many of his views are not too dissimilar to my own. I have always loved the way he holds the very fine elements of a passage together with the most deep rumbling of sounds, with love and suffering and an expansive heart. Who could not love his deeply moving *Songs of the Wayfarer,* and likewise his *The Death of the Children?* This last disturbed his wife very much, and when he said, "It is the death of innocence I speak of," she still was not appeased. In speaking of children and heaven, his concept was that heaven is here now, and that we needed to see and hear as children. What delightful views these are. We are born from a sea of eternity, become lost in time and spend our whole lives trying to find our way back. As you may have seen, it is my view as well.

At one point a person accused Mahler of writing of nothing but death, and his reply was, "a symphony is a farewell to love." In all our creations can be found a farewell and a tribute to childhood—to heaven—and most of all to love. They are the means through which we re-enter the experience of life. It could simply be a tribute to truth. "The soul is deep down in us blowing away," as he states in another part of the film. How to bring that such-ness to the light of day is the question. Good intentions and prayers will not suffice; only action can, and that action may be to be still. Nor will the building of shrines and paying homage to demagogy help. It seems, however, that life can be cleansed of this accumulated grime through artistic expression, but only when it is approached with an empty bowl, in hands outstretched.

———

The sky this morning was orange and purple—bruised; further up there was a shifting of green into cobalt blue, and then, when I looked back moments later, this striking tableau had disappeared. I feel less and less fear that it is gone forever. Childhood's innocence is not forever lost. In fact, the word *being* does not signify mere existence, but new possibilities, beyond our closed circle of ordinary perceptions. It was for something that we were given this special chance. It is the sleeper who awakens the sleeper—this hidden entity that rests within. It is roused by whatever means are available. It is a little known and barely credible idea—but true. This being in us can awaken when conditions are right, and it will in turn arouse us.

———

Moving, Continuing Cycle—2/5/01

The edge of earth worships, through grasses
Which drink in deeply our tears.
Is there a need for tears in seeing joy?
All human joy flows through rivers of suffering,
A flowing together where love again seeks life.
We are breathed into her never-ending length and breadth,
And penetrated by many of her subtle appetites.

It is with great astonishment I come to life. It opens slowly as I am taken from moment to moment by consciousness. It happens slowly so as to protect me from too sudden a shock. This emergence from the sea is quite miraculous.[5]

Endnotes, Chapter II.

1. Robert Henri, *The Art Spirit* (New York: Harper & Row, 1984), 159.

2. Nicholas Hlobeczy (unpublished).

3. Theodore Roethke, *Straw for the Fire* (New York: Anchor Press/Doubleday, 1974), 27.

4. Rainer Maria Rilke, *Letters to a Young Poet*, trans. Stephen Mitchell (New York: Random House, 1986), 23.

5. Nicholas Hlobeczy, from *The Death of Ignorance* (unpublished book).

Chapter III

PLAYING A PART

The ability, and the setting of the stage

I see a resistance, which appears to be beyond my capacity; there is always a need to look for a means of awakening. There is concern to be present when I photograph; some deep secret seems hidden in this. The more I try intellectually to comprehend it, the more elusive things become. I've tried to notice the resistance, and to relax in front of it—even looking at it as a child might. Not being certain seems often to be a part of passing through difficulties—with an open face, looking. Preoccupation with my concerns is not the solution needed.

There is a story about an old man sitting on a porch that may have some connection with this dilemma. The man is quite old and he knows that today will be his last day on earth. He has a sapling he has been meaning to plant for many weeks and has

simply not been able, because of the resistances of his physical body. Seeing the situation quietly and intently, he decides to go against the body. He makes a definite move against this resistance, slowly pacing himself, and manages to plant his tree. It is exactly as he has always envisioned it. Completing the task he steps back and looks; both he and the tree stand quite still. He then returns to the porch from where he contemplates the advancing day—little tree swaying in a freshening breeze, and a newfound joy.

In any situation when working, it is good to make a point of observing—changing nothing. Be an observer without tenseness and note what is observed. Realize the difficulty, and stay with it. In this way—through seeing discrimination, preference, and dislike—it is possible not to act on them. This can be done for a moment, and it is in these little moments that an accumulation of strength takes place. With this non-reactive attitude, strength is gathered, and reactions will slowly loosen their grip. I don't try to get anywhere but *here*—and *here*. A moment of living can be found in each moment of dying to my identified heedlessness. There is an energy that can appear then, and the pictures I find during these times are very different from the usual pictures I take.

———

Play-acting is an integral part of life

Awake or asleep, the mind is filled with dreams. Often my dreams involve an attempt to seek solutions, if not by one then by another in me. Is it possible to be other than split? I want to be happy, but I have only a vague idea of what brings happiness. I seek protection from enemies, but they are mostly illusory.

As children, we were given an indication of what life's arena was for. Here we played all kinds of parts, maintaining a sense of self, participating cleverly, with zest. The sense in acting was not to be other than me, because behind all is the real me. In remembering the experiences of running over the hills pretending to be Wild Bill Hickok in my childhood, I have a precious memory. Those times were moments of consciousness that have followed me throughout life. I did not use these words to express it then, but it is a true experience. My friends, as well, knew of this play without explaining. It was the way we related to each other. Simplistic, perhaps, but this is in essence what the art of acting is. Instinctively in childhood we did know this, and we were gods behind our actions.

Identity, identity, all is identity, and if you are the player then you must be aware of roles. There is the identity you are, and the identity of the part you play—that the crowd sees. These parts are always shifting back and forth, quite haphazardly, when there is a lack of presence. We are always altering the picture of ourselves to comply with the view of others. This need is something that hovers between the footlights and the stage like a ghost, shimmering—never quite real but there. We are totally, involuntarily, identified. One is caught by any prevailing wind; caught unawares, forgetting to tack as needed. We could be prepared and be behind the wheel in this role we play. What joy it must be to play securely in the center, with freedom to move first this and then another way. What a real aim that could be. It would be better than becoming what those around me perceive me to be, which would be playing the part without the child in me watching. It repeats insofar as I am able to return, and the play proceeds—shifting roles—repetitions experienced. What is brought is freedom.

What I often fail to see or understand about children is that they are in balance to a greater extent than I am.

It is natural for them to be visual artists at their level, musicians, and even writers of stories. Unfortunately, this bliss does not continue because we begin to educate them, and, sooner or later, they become lopsided, as we are ourselves. They lose their freedom.

An artist's expression has always been an example of attempting to come back to this freedom—a balance among parts without getting lost in any one. The desire to stay on an even keel is a human trait that can easily be thwarted by our education and upbringing. To return to this balance brings me closer to that seer within from whom we receive love, and even direction in the living of our lives. What can help us if not the seer within us, or conscience to moderate us? Sectarian conventional morality does not do the job well. It is the seer I become separated from in growing up in a fractured world. How can I learn all that is useful to learn in maturing into an adult and at the same time be insistent on this need for balance between mind, body, and heart? Needless to say, in our society this is all but impossible. The discipline of remembering in a craft does help.

———

From *A Night of Serious Drinking*, by René Daumal

Then what do you call actors?

Quite right, I was forgetting. You are too young to have seen any. An actor is what was once called a man who gave over his body to some force or desire or idea, that is—as we used to say for short—to a god who lived through him. He could summon the gods; he could let them flow through his body. Using his mortal frame, the gods could speak with men. They danced together, sang together, fought together, devoured each other on occasions, on others feasted together; in short, men and gods lived together. The actor thus exercised a pure and useful craft.[1]

I need to see what it means to be an actor. It becomes evident that there are moments of this seeing that can take place in our lives. It is not a case of being too young to have seen, but rather of being completely cut off from our childhood. In our growing up we have forgotten this craft somewhere along the way. There are countless reasons. We are endowed with abilities to act that we may survive. The question is, can I regain this birthright and bring it into my life again?

———

Through his actions I can know him

Spirit, within the essence of myself as a child, is rarely seen. I am hard pressed to say I know this essence as a friend. It is so fragile, this delicate relationship, and I seldom notice when he is present or not. What a statement to make. Yet this is the way of it. This bit from my childhood is a case in point:

> *He awakened in the still of night; the house was eerie and silent, with all sleeping except him. Quietly he dressed and, grabbing his shoes, went to the kitchen. He put on the coffee while standing, pulling on his shoes—a balancing act that no longer is possible for him, but which he managed quite easily then.*

> *Here was a child seeking adventure, a twelve-year-old going about his normal business. He had life and things to do and experiences to find. On this morning he was off to the quarry and wanted an early start—to be there for daybreak in order to sit upon the ledge twenty or so feet above the deep water. Here he would be able to watch the catfish slowly circle just below the surface, and listen to the birds as they call forth the sun; a radiance penetrated into his very soul; it was his passion. That was not all, as he had his throw line, weights, and hooks, along with bread for making into dough ball bait. We called it "dough ball" because we kneaded spit into bread with our fingers to make a bait to put on our hooks.*

> *So he would sit, dream, and fish . . .*

He ran at breakneck speed down the hill to the quarry in almost complete darkness, which he had done many times. He knew every bump, turn, and rut along this path. It was exhilarating, but then, arriving there, he found that there was yet the climb down to the ledge to be accomplished, and this was not easy. Once that was done he was relaxed, secreted away; no one would be able to see him, which made him feel deliciously superior. After baiting hooks and dropping in the fishing line there was nothing to do but wait.

The quarry was a lopsided circle filled with spring-fed waters. It was at least fifty yards across. Shallows at one end, where there was no cliff to the water's edge, quite deep in the middle, and deeper still at the opposite cliffside where he was.

A mysterious place, where one day a pile of clothes had been found neatly piled by the high diving board—clothes belonging to a young medical intern from town. He was never again seen. They dragged the quarry and never found a body. Still everyone in the neighborhood swam here, relishing the notion that the intern might suddenly pop up from the depths. It's hard to say what actually happened to him, considering that after he vanished his girlfriend was found to be pregnant. Whether the intern found himself at the bottom of Rock Bottom or cut loose on the open road can only be conjectured. It was more exciting for us kids to think he was in the bottomless deep—somewhere.

It was a cool morning and sitting there on his ledge was a chilling experience. Slowly the sun rose, came over the trees, and was full in his face.

Becoming warm and tired, he finally dropped off to sleep. After some time a gentle tugging at his hand awoke him with a start. It was a catfish pulling at the line. Once caught, the fish was tied off to a branch on the cliff face. He got up, stretched, removed all his clothes down to his bare bottom and dove into the water, breaking the silence around him. Pepper, his brown terrier, had come to look for him and had been on the cliff snoozing, waiting all this time, but now began creating havoc. Finally the dog could contain himself no longer and jumped in after him in spite of the height. Pepper paddled—circling the boy, barking and biting the water. Laughing and barking filled the cavernous space.

————

We seldom return to this stage of our lives, or find its value. Experience can be an arrow pointing in the direction we need in order to be fulfilled. Looking to the past to find the trail is useful. This look is needed to sustain hope; to face whatever difficulties may be found there might well be the solution. It could be a support beneath us for the new incoming impressions, which we need. There is value and mystery in life. It is all a part of our craft. When looked at, it can be seen that all intentional acts are building blocks that support us; it is the play within a play, regardless of the circumstances encountered. It is the stuff I am given to measure myself and to keep moving over slippery slopes. I cannot and must not ignore the negative aspects of things, any more than I can make a photographic print without an object filtering the light that falls on the photosensitive paper. It is a delicate, delicious dance, like running at breakneck speed down a path in early morning's night.

These lessons apply not only to photography

Can all we have been talking about bring me to a relationship with everyday life? Everything gets caught up with the outer or inner life. We forget that we live dual lives, and we live a double life internally as well. There is a world of essence and a world of personality. They need to find a way to live together in one body—in this world. "The aspects of personality are the facets, and essence is the diamond itself."[2] They both can be the servants of something higher still. Playing a conscious role may be the effort needed to be a willing participant in this drama. Behind the role is the seer, and this is most important in a real relationship. It is not just a question of getting along with each another but of finding a means of getting on with the play, getting along with myself, and getting on with life.

The value of having a vantage point

I was once asked, "Why did you choose to live and to be a photographer?" I had no idea what was meant. What was needed to answer this question had to do with looking rather than thinking. Of what value, then, is thinking? It seems there is a kind of thinking in me that brings nothing of particular value, only repetitiveness and more that is stale. In silence there is a communication with the immediate—that which is timeless. Here silence can be experienced as bringing something—a new looking at what lies before me—a thin thread that leads back to the source. With this I am entwined with intelligence—with a new sense in the continuing play of forces. With all my experience, I do not know why I chose my direction or if indeed I did. My keenest realization may only come when my state changes.

One of my favorite philosophers said, "The happy person is one who is striving to actualize his own potentialities. This is the aim for which you took the trouble to be born."[3]

I wish to be a part of things. This choice is filled with the sense of wonder and an awakening of conscience. Could this bring a rebirth of values that sleep so deeply in me—values so far away that they seem to come from a previous lifetime? Through silence I might see this past life of mistakes, taking it in a much less personal way; then my regrets can die. To engage in living would be to discover the mission I was born for—to become "enabled." Being comes out of the abyss; it happened fourteen billion years ago, and into that silence being will return.

In the meantime there is the play—a mud-luscious play to be played. It's like that. In childhood we played with mud, making our own pies and cookies—laying them out in the sun to bake. In that play we found a luscious joy. My own millisecond on stage is happening right now, mostly not seen. I hope not to muck it up. My vantage point is in the wings, and I need to move on stage, into the fray. When I find where I have been misled, I shake up my bones. To die to that false step and attempt to carry out what is needed is the aim. Deep in my life is a wealth of impressions that can be brought forth. They include embarrassing moments, as I have indicated. It is useful not to refuse anything, so I wish to use reactions to help me look. Passiveness and lying to myself make no sense at all. Receiving the image and moving on is essential.

———

I respect the seer as a special entity. He is not a part of my personality, and I did not realize the truth of that to begin with. I've not noticed often enough this quality of

lightness and timeless patience when the seer is present. Yesterday He was not present . . . I felt an aching, gnawing feeling of being incomplete, and hollowness when I noticed this and for the rest of that day. How utterly strange it is to comprehend such a situation. In sitting quietly in the evening I became filled with a sense of loss, as though I had done something unforgivable. I went to bed with that sense. During the night I awoke and experienced at once a feeling of well-being that had not been available all day. It was then possible to put together some of what I've written. Remembering more often, or, as is sometimes said, being remembered. I can say with a degree of truth that this writing connected me with the seer. Now is the time to kindle that small flame, rather than smother it with the damp dead debris of my knowing. To be in question, not just in words but felt physically and emotionally as well— it's just that which keeps the image in front of the camera, the play, and me. My own guide said countless times, "Nick, it's a hands-on experience." Imagination is not where the value lies. Imagination can be useful, but not when it serves the purpose of avoiding one's nature and the real world.

I experience a taste of all this in photographing. Even so, what is present in these experiences is not seen clearly or entirely, and I still "take credit" at times: I need to remember that I am the arm and that the seer within knows what needs to be acted upon. Can that realization be a guide to creativity? Who in me moves the brush when painting? The heart? Or does the movement start in the pit of the belly?

This gentle quality that can be experienced—of the seer—is a big reason for my working in photography, as it helps me to realize a higher intent. In this I find a sense of belonging—not being left out. Also seeing without prejudice brings a new glimpse of freedom, a freedom from being suppressed by my hang-ups. Desire alone will not

make things right, as desires change constantly. Of course, desire is still boss in personality; that is where these desires live. To work in a new way requires special looking and determination, and in that work my personality does not have a right sense of direction.

———

There is a meek side of the psyche as well as the brusque; both need to be seen, because they appear to get in the way of the living quality I try to embrace. I realize this seems odd to say, but we are both; I am enabled to work only when able to be open to both. It is a thin line upon which to tread, and it is quite easy to slip into imagination on this matter. The creative includes the participation of all the senses, not just the eyes but also the sound of words, the movement of mind and body; it is not automatic. At the same time, without a little silence how can there be listening? How can there be feeling? This is true of everything. If there is no quiet, there will not be more than a superficial impression, more connected with imagination than with actual truth. Staying with the impression is fragile.

———

This play called "existence" suffers all, with little relief from me and my rash states. Here our suffering can be revealed, and our humanity as well. It is not that something was fashioned badly, but that something wonderful and good was given at birth, and in my careless hands turned into something quite foul. It is midnight in the garden of reason, and excuses prevail. As things stand, without effort upon this stage, the play is played without me. I abandon myself. The dark side can be camouflaged, and it is

deeply hidden. There is no hiding when it can be seen that having disrespect for others and myself has such a taste—a poison for which there seems little antidote—except possibly remorse of conscience. In this may be a possibility. We can get very much down on ourselves, and that does not help.

————

I am moved by a play of E. E. Cummings because of its childlike qualities. There is a romantic sense of things here as well that attracts us in youth that often, later in life, can bear fruit. At times this almost seems in opposition to reality or truth. There is a kernel here worth looking into. There is a kind of self-pity expressed in the play—mixed with a romantic notion of redemption—heroic in nature. While all my friends were busy thinking of becoming doctors, lawyers and engineers, my own inheritance was a sense for the arts, and that was not considered to be *really* important. So I made a virtue of being different. And it appears that my refuge became a cocoon in which to grow and regenerate—to find a real value in being an artist, and to not feel sorry for myself. My notion of being an artist is not the same as in youth. In a way it is a mystery how this could change me, but it did.

A play by E. E. Cummings called Him

> Him: Damn everything but the circus! (To himself) And here am I, patiently squeezing fourdimensional ideas into a twodimensional stage, when all of me that's anyone or anything is in the top of a circustent.

> Me: I didn't imagine you were living a double life—and right under my nose.

Him: (Unhearing, proceeds contemptuously): The average "painter" "sculptor" "poet" "composer" "playwright" is a person who cannot leap through a hoop from the back of a galloping horse, make people laugh with a clown's mouth, orchestrate twenty lions.

Me: Indeed.

Him: (To her): But imagine a human being who balances three chairs, one on top of another, on a wire, eighty feet in the air with no net underneath, and then climbs into the top chair, sits down, and begins to swing . . .

Me: (Shudders)

This play continues, and toward the end Him comes to a conclusion of sorts and says:

—I breathe, and I swing: and I whisper: "An artist, a man, a failure, MUST PROCEED."[4]

———

There are flaws in the way we see things as adults

In childhood I saw many things without judging, and delighted in them. As an adult I am nothing other than evaluation. The spirit of myself as a child needs to be reactivated, and can be with right effort. When working, there is a need to be simple and available. When the child is present, the image appears. As in looking for agates on the beach, the impression is direct—just as the agate's impression of the sea itself might be were it conscious. These impressions are conversations and can be transforming; they have their effect, as surely as the sea polishes agates. There is much to learn and question beyond the veil of appearance. The camera is a tool guided by my attentiveness and presence. And much can be transformed.

Experiences in childhood would not have been possible without innocence—without an attention attracted by feeling. What was simple and true in childhood needs to be paid for as an adult. Pictures of substance (*image*) do not arise on a whim. It could be remembered that expectation brings attitudes and resistance. With a child, expectation is boundless—but is without guile. There is a need to be simple, available, and to accept what is. When I am open, the image appears; in the meantime, there is the friction and the same kind of glowing beauty that is found in agates.

Our ego has other things it thinks to be serious; believing in ego eats away at being alive, through forgetfulness, imagination, and self-indulgence. It may be that a serious direction would be to learn how to become the actor we have been talking about—to play the part fully and let the devil take his due. With my brand of seriousness, my desire is, at all costs, first to defend the ego. We excuse ourselves by not making allowance for anything to be felt other than our selfish wants. In this way we do not

allow others to play their parts, unable to see that there is no play without the inclusion of others. A world without relationship and empathy is a pale place and sorrowfully sterile. It would be fun to be an actor on stage, exciting and rewarding. It can be so with my photography. All the aspects of that role can be filled with reverence; no stage is necessary. It is as René Daumal said about actors, "Quite right, I was forgetting. You are too young to have seen any."[5]

But now—we can remember!

Endnotes, Chapter III.

1. René Daumal, *A Night of Serious Drinking* (Boulder, CO: Shambhala, 1979), 62.

2. A comment made by a friend of mine in the Gurdjieff Work, Ronald Ross.

3. George Ivanovitch Gurdjieff, *Beelzebub's Tales to His Grandson* (New York: Viking Penguin, 1992).

4. ee cummings, *i, Six Nonlectures* (Boston: Harvard University Press, 1954), 79-80.

5. Daumal, *A Night of Serious Drinking*, 62.

The Experience Concerning Time's Nature

The Sun's Light when he unfolds it
Depends on the Organ that beholds it.

—William Blake, *The Gates of Paradise*

Real seeing moves in two directions simultaneously. This is a land where time and ordinary judgment sleep and where insight prevails—a place from which true action comes. This morning there was a faint glow in the eastern sky, yellowish, and slightly orange closer to the horizon. I said hello to its awakening. The thought about real seeing came to me this morning. This thought lifted my state out of the pit of despondency. It is what I wished for.

Some truth and some flaws in my seeing are found—creative audience

Find the image with heart and eye, and then carry through the picture-making process with the mind; this is what I must try. I need not interpret the content of the picture before me. This action allows the heart its own becoming. My collection of *image* is stones, water, and branches, along with stories and poems. All these visions and revisions become seeds—striving, searching for expression. They are strung on the fine thread of my breath; in this way they are locked in time. In order to observe them better I need to be outside time, which would be free of the entrapment in my subjectivity. I need to be engaged in an all-encompassing seeing of both object and subjective self. The place from which we see is other than what we think it is. It is important to be more discriminating.

———

What we call "seeing" can be flawed. It can become a form of self-indulgence. There are false notions of truth that can bring evasion, but what kind of vision would that be? It can be a means of running away into other imprisonment. An example: the act of judging others, by its very nature, omits self-scrutiny—seeing ourselves. How then can this be accepted—this one-directional seeing—this failure to look more than one way? Only the practice of dividing attention will do. It is said that truth sets us free; this aspect of beauty is little understood. There are moments when perceptions are stretched by life circumstances, which can allow a more conscious vision. It is a wonderful experience to be given these gifts. In that experience is an ability to see truth— and, in a way, even justice—for an instant, but gifts are not always available. I attempt to see the subject as myself, as I also am this. And an effort on my part is needed. Many

people march to different drummers—they're so busy perceiving everything in their own light that nothing is perceived. They are in bondage to one-sided views. It may be that wisdom begins at the moment we accept that we do not know in the face of our "knowing." Invincible knowledge cannot be enlightened. Truth is not a personal property—it is not owned by me . . . dual perception is an important lesson to be learned along the way. It is necessary to be aware of myself and the subject simultaneously. Accuracy in what I see depends on seeing myself. It is the mark of being human to do so. None of us thinks in this way automatically; it hardly crosses our minds.

————

What about reading books? Do I feel a need to follow closely by putting a flashlight on myself, as though I were the writer? Is the old-fashioned notion of sitting back and being entertained really all that resistant to getting out of the way? There may be a new fashion: we might try thinking. It may be that thinking is even more rewarding than entertainment. Thinking may even invigorate, while also being relaxing. In the end, I might not agree, but I could gain a new understanding of the writer's experience and a new insight into myself. There is something useful in this kind of study, but usually what I grasp after is only an empty form, like a computer that constantly returns to an ill-chosen default mode—always searching for entertainment, or ease. To be an audience of one, which is also what I am speaking of, may be a cardinal rule for this new view. Attendance is essential. I will need to understand more about *creative audience*, because my passivity does not help.

Personal insight and abilities

Creativity is centered on the play, and the artist is the protagonist. I am the foremost character in the spotlight of self-expression. In this play conditions are created in order to explore the possibilities, not only to mime others. The creative process requires that an audience be in attendance—what I call a *creative audience;* even an audience of one, which is myself, will do. Passivity will not do. The play reflects; it reveals intuitive nature, and it can be recognized that what is produced is reflective of the individual—of its creator. It becomes the mirror. In seeing this expression as a mirror I can become intensely interested. Who else is in the mirror?

In our looking we see the need to search for balance, and as we look we are being enabled. From this point of view, it is evident that something new might be understood. The product that we bear to watch—the painting, the sculpture, music, the photograph or the play itself—is a result, which came from the artist's time and attention. The re-enactment can be sensed from outside that time. The audience becomes the living, evolving reality of the present moment. In this process the audience is able to play all parts.

When I am the active audience I can be helped to see myself. It may even have further value—to discover that the eye is drawn by my own nature—or, perhaps, by automatism that takes charge. There is little or no intention that directs the eye. Seeing this, we can find opportunities to change and expand through greater attention. It is not easy to see my weakness of intent, let alone direct my intent. It may even be impossible, but without a wish for inner freedom, and a search based upon it, how can I know what may be possible?

Generally we go to museums to look at Rembrandt, Goya, or Van Gogh, but it might be possible to go there seeking ourselves in those mirrors that have been handed down to us. The mirrors that have served these men in their lifetimes might also serve us. These mirrors cannot be fathomed at once or completely, but are of such an organic nature that they can grow in the hands of the user. They are a constant wellspring filled with treasure. With a new balance there is a new possibility that can come to the artist from a higher nature within. What is needed is for thought, feeling, and common sense to be participants. In participating in this balance, I am able to open to a finer nature which seems to be outside time. We cannot make art; we can begin to see that we receive it; it is transmitted from a place of the finest vibration. The more I have investigated these things the more obvious it has become that an artist is a custodian and a good servant of that higher nature. Such practices as I have been outlining can definitely help when one picks up the camera.

There is this constant question—how to search. It is a good question, but I need to be careful, as desire can betray the looking and destroy insight. At the same time, reason says it would be useful to see what draws me on. What do I grasp at when engaged in the play, and in my craft? We become animated with interaction, relationships arise, and sometimes this very kinship interferes, throws us into dreams about the subject. This is true at times when I am searching for pictures. When the looking turns into desire to possess, it can blind me with dreams. I see and realize that when clarity is lost the connection is severed. When I actually search, it is approached as a study. Like saying, "What is happening?" There is a return to this question again and again. When some answer is found, I respond with ". . . and what else?" When another answer comes, I again say, ". . . and what else?" It is not boring, but you will need to verify it for yourself. All the questioning burns away desire; what is left is experiencing, and at times a new image presents itself.

There are no questions or vitality when I am passive—an automaton takes me. But when I am actively still inside myself, sincerely cognizant of my situation, many things can open. We are not aware that we are held captive by automatism and habits. I could begin to realize this to be a fact. Where I am, how I am, and what I am now doing can be in view. Generally, we are taken in whatever direction the wind blows; active mindfulness does not function unattended. At times there is an impression of myself—and nothing is there but reaction. This perception connects me with a certain feeling toward life, a feeling that is most often missing. This experience could bring curiosity about the role of mindfulness. To what end do I watch? Perhaps to no end but to continue and to comprehend the direction the wish is coming from.

One can never assume to have understood . . . that might be rationalization, or an attempt to place myself in a favorable light in the eyes of other people. We all want this. When an argument breaks out, we feel betrayed. On the other hand, this does not mean we need to behave badly toward our fellow beings and believe they understand nothing. Openness toward others is a major task, because religious ethics, or someone's ethics, is always getting in the way of sincerity and compassion. An understanding of truth would be a direct impression that I am no different from you. We are equal when we are equal to the task. That would be right on the mark. To actually have this experience would be a major miracle. It is just such an uncomfortable thought that can help us.

————

Noticing we are not simply cabbages; we are a mixed bag

Cabbages will be cabbages, celery is celery, and carrots never change their minds about being what they are. Together they can make a fine mother's stew. We may all feel this—that our stay here on earth is a stew in which to discover our true calling. Are we so desperate to find our place that in our zeal we end up excluding others? Surely variety is needed to make a good stew.

Each of us prays for salvation, relief—whether he admits it or not. It is very interesting to see reasons for this in my behavior. As an example, I think of the "damn rain." But it is in me, not out there happening. That is the more real concern—how I take it. Likewise, summer heat without air-conditioning can be bothersome. To move with the flow seems the best of all actions. It might even bring long life, and perhaps even happiness. As for salvation, I would not count on it, unless you see salvation as acceptance. That would be a lovely salvation, and it would do something real, like easing my tensions.

Directing attention onto what is brings a brief moment of clarity, of moving with— and at times even against—the flow, without being tense about it. When trying to gather myself together, there is a mutual sharing with the body through sensation. Then there is substance, a sense of what is. In this trying there is a deepening impression of physical presence while working. There are still reactions but there is this additional element—my body with all its senses, and me in it. It seems that an attentive state is not just physical or mental but includes both and maybe more—perhaps even feeling. This alternative state offers the possibility of a new kind of insight—that of an observer of this helpless participant that I am in my everyday life. That which observes

is not identified with the ongoing processes in the head but is capable of perceiving these processes and sensations in the body. Because of this, a more expansive examination becomes possible. I find that I am in the middle, between two parallel worlds—the world of the mind and the world of the body. Pointless reactions continue to make their noise, and yet there is also a quiet. I feel torn between the two, so I concentrate on what is—this peculiar question, which is myself, me in the middle.

Part of me is very attracted to reaction, which gives me a certain liberty to drift with the ebb and flow of things. The effort of directing attention must be repeated often because again and again there is reaction and a forgetting of what I am attempting. It is often difficult to try, and effort is short-lived. Attention cannot be maintained automatically; that is not in the nature of things. Can something encourage me to retain attention? I am the mystery, and photography can be like a little knock upon the door reminding me that there is, in fact, a door leading into the mysterious. Behind the door is, perhaps, silence profound or a sea filled with pictures that I had not seen till now—maybe both.

It has been asked of me, "Is there a way to be of use to oneself?" To recognize what is involved in this question is interesting. To be awake, for even a millisecond, would make it possible to be a more viable craftsman. With this kind of effort I could say more honestly that I am involved in the special business of *camera work*. Is it useful? Yes, because I need to be useful to myself before attempting to be useful to others; *camera work* does help me move toward that possibility.

———

Aspiration and the creative audience bring helpful change

In my creative photography classes, I made it a principle to always begin with being still. This principle is a means and was never intended to be an absolute. However, what I said to my students was:

"Being still in the field, in the darkroom, behind the camera with the picture before you, is needed. In the viewing of your proof prints and final prints it is likewise useful. Employ this approach when viewing another's prints, in beginning anything you engage in—it helps. One starts at that beginning, sounding a note of silence. At the very best, I can say that being still—being quiet for a few moments before study or a given task—will set the stage. After I become quiet I will perceive more clearly what it is I am about to engage in."

———

When viewing prints or any work there are questions I ask: What thinks in me, where is feeling, and where in my body do I experience it? Empathy becomes a precise tool by which the *image* aspect of the photograph can be entered, rather than something I am dragged into blindly. Although it can be fun to be caught up and swept away, it is a far richer experience to enter intentionally. All people know this intuitively, but most have forgotten to pay attention to their organic intuition. How else are we to usefully put ourselves in the shoes of another, or become a tree standing in the woods, except through such practice? This becomes a point of inquiry for the photographer.

Intention enlivens experience, including the act of sharing these experiences with others. Teaching is a learning tool, and much knowledge can come to light through mutual inquiry. To teach, there is a need to become a student among students, to ask questions and be asked questions. We need to be able to empathize with each other as well as with the content of the image. All is a play, the stage for transmitting our discoveries.

Learning to work within a format is helpful; however, we can transcend these borders at the time of exposure, and even know in addition how the final picture will look. There is an idea about the format of the mind as well. Though we do not comprehend these boundaries well, we see as much as we can, and, in general, make poor judgments. Learning with greater exactness, we can begin to see the format slowly open. Transcendence goes beyond personal inclinations. It is rather special and requires, at times, the help of others. It is true we can push at these borders and include many more things through self-study. *Creative audience* can be a part of that study. There is always more hidden inside and outside. To find myself beyond restrictions is liberating, but to break through these restrictions I must know they exist.

Our body can be thought of as a camera with many limitations. There is restriction because we are so unacquainted with the body. Its willingness to become receptive can be studied. Awareness of my limitations—seeing more of what my body does or does not pick up—will help me go beyond constraints. This kind of knowing can be verified through experience; what you believe or disbelieve is irrelevant unless you have verified it. You are able, to a degree, to find out for yourself. Have you experienced "something" in you that sees beyond your ordinary knowledge for one split moment? What is that? This experience can be a point of entry. Unlike a camera, bodies are organic, and as such are constantly in flux. In addition, they grow.

Personal images are important. They bring material that leads to self-knowledge. I often refer to my images as probes; they are used to see more clearly the way I feel, think, and have a sense of myself. Images will and do serve as mirrors if we allow them to, and they can help us open to questions. There are many photographers who work in this way, and in so doing experience a greater freedom in finding pictures that aspire to become *image*. Don't throw away those pictures that you consider not to be public pictures, because they may be the seeds of future images that are.

———

I wrote a statement about creativity that was published in *Aperture*, issue no. 95, called "Minor White: A Living Remembrance."

> *When a photograph comes from that which is called the creative it gives nourishment. This also makes it possible for the viewer of these photographs to come into touch with the creative. At such moments a poem, a new photograph, or any serious response is a rebirth. In this, somehow, can be a way of touching that which is immortality.*

Here this idea is corrected from what appeared in *Aperture* magazine, and I do not know from where—in meyself—the responsibility for that previous statement came. In any event, I have changed it here, and it expresses what was intended. Within this idea is the possibility of *creative audience*, which I feel very strongly about because with *creative audience* we can go far. This is one of Minor White's many contributions to the teaching of photography, and I employ his approach and have made it my own.

Artists in the Japanese Edo period made provision for a *creative audience* in a rather wonderful way. When a work of art was finished everyone was invited to a gathering of poets and fellow artists—a gathering of peers. They drank together and celebrated the completion of the work, adding to it by writing their comments about the work of art at the tail end of the scroll—poems were written which were works of art in themselves. With this ritual one became part of the human family, the community, and experienced completion. Here was a new beginning. When we gather to ponder our experiences together with photographs, there is a force, an energy, that can provide food for all, and certainly for the individual photographers themselves. It is a part of the "waxing and waning cycles," as in the moon cycle. One is encouraged and refilled with new and fresh impressions by the process. This is what *creative audience* is all about, and perhaps even more.

———

A little summation

What holds it all together? There must be a thread that brings comprehension. There is a need to find sound reasoning. We secretly all wish to be part of the human family. Nature and cultural events have given me tools which could bring this connection, but along the way I may have become lost, overwhelmed by all the tools that have been given. The fault does not lie in the tools but rather in my application of them. A myriad of competing goals have materialized in my erratic mind. It's all very well to talk about beauty being in the eye of the beholder—about perception and seeing—but there are a hundred and one things that lead me astray. Where is my own eye?

To find my way I need tools, and to acknowledge what it is I want. It is necessary to be attentive. I need to work at playing my part and to have an aim; then there are questions of a special kind. Such a question can be a thread which leads me through the labyrinth, preventing me from getting lost. There is as much joy as my attention, insight, and perception allow. And along the way there are the photographs.

———

About those works that come into my sight

My photographs, these by-products of my effort, these images in many ways are my children, but once conceived they can be set adrift in the open sea to fend for themselves. If they meet receptive minds and hearts, they will continue on their way through time—with help from others. In a manner of speaking, they have the ability to feed others, but to do so they need to be touched by perceptive souls. If they have not been conceived well, they will perish, no matter what I can say in their defense. The lives of these children of mine can go on beyond me in time, but who can say for sure.

———

Another morning, and the wonderful sun is still with us; beautiful fall color complements this atmosphere, and in the background are many days of quiet wonder that will come—autumn rains will come. We might argue as to why He did not make us more perfect, complete as nature seems to be. This may be what philosophers have been arguing about for ages. However, there is a certain evolution that depends on us. If this is true, it is most difficult to find.

It could become more and more apparent that everything does not come together without being paid for. Seeing this requires a push from me. What is amazing is that art, when taken seriously, attracts a force from within that can become my guide. It is a friend whose company I begin to cherish. With it comes a clearer understanding of the necessity of payment for that guide as well. We are very fortunate even to experience life. Yes, there is the gift of life, as people say, but to experience it more truly requires certain and necessary payment.

What we try to carry on with is something that has been a part of tradition for countless eons. We put a new face on it, but what we look for is a consciousness inside ourselves that has been lost in the process of our growing up. Each of us is different in how we lost that "something," and each finds his own unique way of return. Like the Prodigal Son.

ENTITIES . . .
WHEN IMAGES BECOME PEOPLE

They are quietly speaking

The not-so-silent conversations between things are always present. What is not so often present is my sensitivity to these voices. As it is said, for every push there is a pull, with every affirmation denial, but with only these there would be nothing but a frozen, rigid wasteland. There could be continuing movement with each new balance point experienced. There is great beauty in this ever-shifting dance. This is very alive and transcends all notions of a static existence. This is what brings life, for without it I would be locked in without possibilities; there would be no sense of creation. All would be frozen before the existence of time, without realization; there would not be a universe. Fortunately, all is conversation and movement—or transformation—that awaits my awareness. There are many entities all about us. I refer to those entities as

image (photographs that aspire to say something); they are symbolic cameos, or icons. They have an unambiguous influence upon my life—they move and their movements are instruments of transformation.

———

Everywhere there is evidence of growth

Evidence is always available, waiting to be found and investigated. We see traces in the expressions of others—and sprinkled everywhere in nature, a little here, a little there.

In Patrick O'Brian's book *Post Captain*, there is a passage written about one of the characters, Stephen Maturin:

> Stephen sank into an agreeable languor, almost separated from his body: a pair of eyes, no more, floating above the white road, looking from left to right. "There are days," . . . he reflected, "when one sees as though one had been blind the rest of one's life. Such clarity—perfection in everything, is not merely in the extraordinary. One lives in the very present moment; lives intently. There is no urge to be doing: being is the highest good. However," he said, guiding the horse left-handed into the dunes, "doing of some kind there must be."

And again:

> This is perhaps the final detachment; and this is perhaps the only way
> to live—free, surprisingly light and well, no diminution of interest but
> no commitment: A liberty I have hardly ever known. Life is in its
> purest form—admirable in every way, only for the fact that it is not liv-
> ing, as I have ever understood the word. How it changes the nature of
> time! The minutes and the hours stretch out; there is leisure to see the
> movement of the present. I shall walk out beyond Walmer Castle, by
> way of the sand dunes: there is a wilderness of time in that arenaceous
> world.[1]

———

We wonder where time goes in moments such as these. It is as though time stands still
and proceeds at one and the same time, like being pulled through a black hole.

> *Like a caterpillar, I still continue to weave a cocoon for my chrysalis. I work*
> *in the deep night of the soul in order to fly or to slip into silence, that silence*
> *I arose from. The center is always silent, and this truth flies within the storm*
> *on its own wings. Along the way are many experiences—many pictures that*
> *inspire me.*

This is the way I ended a note to a friend explaining what I see to be the truth—my
own peculiar way of looking at things. It is a metaphor that expresses the desire for
self-development and love for the silence within all things. So, when looking for truth,

do I turn my attention toward the wind that drives it? It seems important to always be in whatever is, between opposites and not reacting, just being still in that center—being alive within one's own cocoon.

Said another way: It is necessary to be in movement within the wind, not reacting, but flying without being distracted by judgment or analysis. All is poignant and what is in fact needed is to be of service, simply to serve and to experience the need of the moment; this is what can enable me, not only in appreciation of the image I discover, but also in the activity of my photography. When I find this beauty in my movement and my work with camera, then there are special moments—here time vanishes. Could this be what teachers of old called eternity? Many thoughts flit in, as though from a more subtle mind.

———

Some examples of conversations between things

Blood of Christ

As I was walking down a gulch in Utah at dusk, my eye was caught by some sulfur markings on a cliff face. That evening of photography had not been eventful. Nothing had attracted me till that event, and now this possibility—along with low light-meter readings! Very likely it was the low light level that enhanced my experience. I wasn't quite sure of what I was seeing. Did the image catch my eye, or did something in me send me the message to look at it? Earlier in the day I was given the idea that an image can say, "Come take my picture." Now, trying to verify this experience, I see that this

is not quite so. Interrupting the questioning, I just stopped and looked. In considering the light level, I had no idea whether the picture could be made, but I opened the lens and kept it open till dark—perhaps ten minutes. Drinking in the mood, I just stood quietly. My doubts about an image having caught me began to change, and part of this change of notion was a strange feeling of not being quite alone in my picture taking. When the exposure was finished I returned to camp quite elated, with a sense of fulfillment. When Minor White saw me, he asked, "What bit you?" I smiled and said, "Someone in me took a picture, and I don't know who he is." Minor's response was an even broader smile. He continued making our salad for supper while I shredded carrots to add. He kept glancing up at me but didn't say another word.

Developing the negative a week later, I found that the picture did record after all.

———

Steps and Reflections

There is another picture from a second trip to Capitol Reef that I cherished. I found this image the very next year while walking down the all-but-dried-up Sulphur Creek. The creek had windy little twists and turns with cliffs and scattered pools of water, for the most part not interesting to me. The area was primarily in shadow, as the sun had not invaded these pools yet—brilliance was absent. I sat down to be quiet and watched some cliffs slowly begin to be reflected on the surface of a particular pool. Slowly the scene changed with the coming of light. At that moment I had no idea where these bright cliffs might be. I was still in shade and so was the space around the pool—quite mysterious. Quickly I set up the camera but only had time for a single exposure. It

only later became known as "Steps and Reflections," which is what I call it today. L. K. Andrews at the Ninth Yolo International gave the Best of Show Award to this picture in 1964. My statement at that time was: "For me photography means *camera work*, and in these two words is the idea that photography is a means whereby a person may see themselves, to know and to learn, and perhaps some day to come face to face with their Creator."

That was almost thirty-eight years ago, and I still see it that way, even though I have not seen the Creator face to face.

———

Easter Tulips

I walked into my office at the Cleveland Museum of Art one spring morning, and on the corner of my secretary's roll-top desk was a bouquet of tulips. They were lovely— tea rose in color, and like a singing choir their mouths were wide open. I asked Nancy Schroeder where they came from. She said the guard at the security door had seen them in the trash bin, thrown away, and rescued them. He imagined she might like them for our office. As I looked again, a strong urge came over me to photograph these tulips. I thought to myself, "Such flowers—glowing, singing—in a dim office." Before I took off my raincoat I brought the 4 X 5 camera from the studio and I made a negative. I made two exposures as a precaution. I said nothing about what I sensed about the tulips and simply said how beautiful they were. I sensed this impression as a gift we were lucky to have, considering the act of fate that brought them to us. Over the years these "Tulips" have lifted many hearts, though no one has known their history. Imagine what that guard might think if he knew how this small act became a gift to many.

Two Leaves

Image springs from all kinds of things, even arguments. One happening weaves into another at times. By the thinnest of threads things sometimes turn out quite nicely. I remember a conversation with Minor White on the telephone. He challenged me for having given an assignment to my class that he felt I had not experienced myself. The conversation ended without resolution. I was upset, saying to myself, "Teach? Why even try?"

Looking out the window of my living room, I saw our picnic table on the patio. Minor liked sleeping on that table when he passed through town, returning from the West. He hated to return to sleeping indoors after having camped outdoors for weeks and weeks. He preferred the outdoors. On the table now were wet, soggy leaves, which seemed to be swimming in an overcast sky. No solace here—the scene echoed my feelings. Still disturbed about the argument with Minor, I decided to go into the backyard with my camera. I hoped to get over being upset. The leaves on the picnic table again aroused my attention. A quiet sense of movement came upon me. I focused my camera on the leaves. I chose a low angle because it brought out the reflections in all the wetness around the leaves.

My choice was two particular leaves isolated from the rest. Two damp dead leaves that set me to shivering in the fall air. What an unlikely pair—yet there was some attraction. What was it? I didn't know exactly but made the exposure anyway. With the black cloth over my head, I reopened the lenses. I was awed by what I saw—everything became completely transformed. The leaves were glowing. They had come to life in a most astonishing way. I remembered the assignment I'd given my class; obviously,

it was never completely forgotten: "In photography there is black and white. What holds them together? Find a picture of this." Suddenly I noticed there was no longer anger or agitation in me. I saw in a clear way what the assignment was. It simply pointed the class in a direction, to see what discoveries they might come to. Now I had verified the value of it for myself. It is not only one's image that can be held together. This expressed a multidimensional sense that self-realization is possible.

————

Island

I found "Island" while walking the beaches of Oregon—Neptune Beach, to be precise. This photograph has many layers of meaning. My wife Jean and I had all but missed the ebb tide that evening. As the water was now flooding the tide pools it seemed that everything I would be trying to become acquainted with was about to be spirited away. There was a solitary rock on an open part of the beach. I quickly set up the camera, with the waves moving closer and closer, and looked through the lens to see not a rock but an island. I thought to myself, "This is too corny, too ordinary." Then the sun moved; the beach glowed velvet with light scattering through thin clouds, and the barnacles on the little island became more distinctly visible. I saw the calm sea around the island, but the sea and the foam were advancing quickly. I made the exposure, and all was flooded a short time later—including me.

————

Empty Cup

The experience above reminds me by contrast of an image I found many years ago, one of the earliest I took with my large format camera. I call it "Empty Cup," and yet it is much more than just a cup. It speaks to me; it is steeped in metaphor. It was found in an abandoned farmhouse in Michigan, in what had been the bathroom. Dust on its rim—dry, dark, and mysterious. Surrounded in its little world—a silent void, a cup without a master. Somehow these two experiences—"Island" and "Empty Cup"—are related, are brothers under the skin, connected and connecting me to some purpose. I never seem to be finished with some photographs. I see myself finding my way through more and more encounters with such entities, as I call them—little worlds without end.

———

Transmutations

While on a visit to Florida I was asked by my friend Carl Parasility if I would like to see a banyan tree that was special. Carl is a devotee of Jackson Pollock, the painter. He wondered if I could make a photo for him, so we went to investigate. The tree was quite beautiful and expansive, which prompted me to make several negatives. The details of the tree attracted me because of the strength expressed in the movement of the branches. Recognizing my appreciation while working around the tree, Carl explained that there was another tree I might like as well. So we drove several blocks further to this next tree. He sat in the car while I spent quite some time viewing this tree. It was all but dead: branches had been cut off—initials had been cut into it and

also people had painted their names on its many trunks. Some of its branches were propped up with old boards. On the opposite side of the tree there was a great splash of paint.

When I got back into the car, Carl asked why I hadn't photographed it. Hardly knowing what to say, I thought a moment and said, "It is a sacred place. Somehow photographing it would be a violation. This tree has put up with much, and now why should my probing be added?" The actual point for me was that the tree had great dignity in spite of these violations, and I felt incapable of expressing this dignity. In addition, it is always difficult to see things as others do, and I guess I skirted this issue at that time through my evasion because I felt it would make my friend feel better.

I discovered later that the first tree I had worked with had not yielded a successful picture. Although I failed, I did acquire something in these two instances. I saw that social commentary is not what my work is about. This was certainly true with the second tree. And as for the first, it is not possible to fulfill the dreams of others.

The next year I visited the same trees, and out of that final visit with them came a series of images that spoke to me. The series was called *Transmutations*.

———

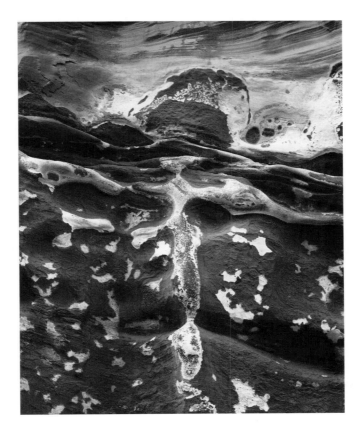

IV - Blood of Christ - Capitol Reef, Utah - 1963

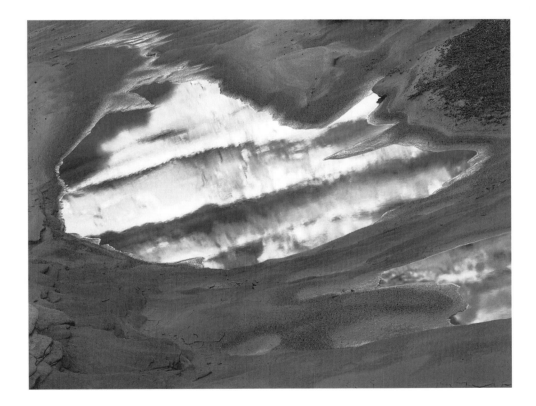

V – Steps and Reflections – Capitol Reef, Utah – 1963

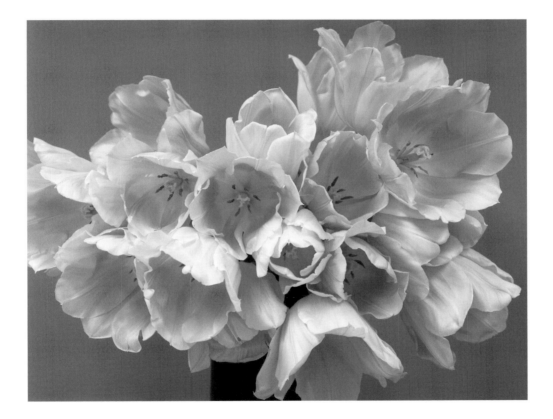

VI - Easter Tulips - Cleveland, Ohio - 1972

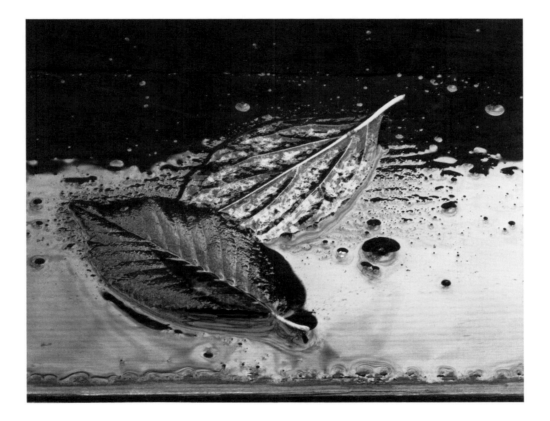

VII – Two Leaves – Cleveland Heights, Ohio – 1972

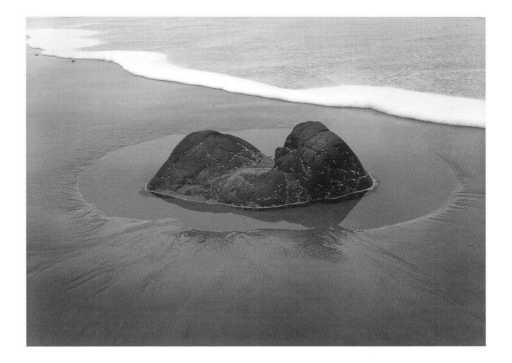

VIII – Island – Strawberry Hill – Yachats, Oregon – 1999

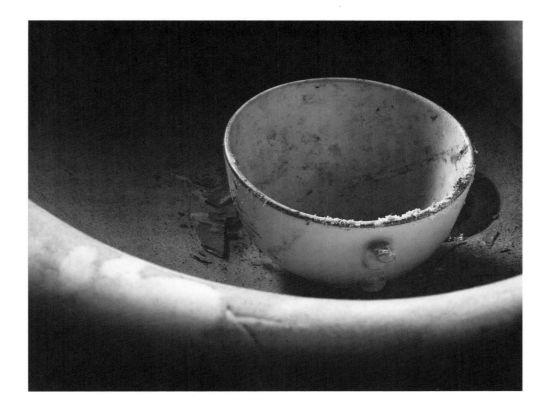

IX - Empty Cup - Monroe, Michigan - 1962

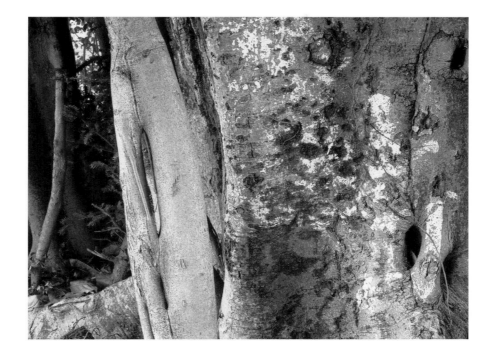

X - Transmutations - Hollywood, Florida - late 1990s

In these examples of exchanges with photographs there is a question regarding whether the conversation is coming to me from the subject or I am talking to myself. Both are happening, it appears. At times I seem guided; there is a resonance, and often I do not know from where in me the light of recognition comes. When there is truth—not just reaction—there is a connection with the subject, and feeding takes place. It is very difficult to see the difference between subjective and objective other than through this sense of being fed. I call these experiences "encounters with the *seer*," and as such they can touch and influence me deeply. Some people might not call this experience objective, but my experience is not influenced by them or by social considerations. Hopefully, these images can speak to others, as they did to me, without being obscured by social conditioning. It is not change in society that I wish to bring attention to but a deeper experiencing of the *seer*.

Art in its many forms does lead to a growth of understanding. I wonder if this was the push that moved Paleolithic man to create objects and symbols. Could it be that these were expressions of the *seer* within them? We are all the better when related to art; it brings a sense of freedom to the viewer as well as to the artist—a sense of our reality together.

Art can cause confusion though misdirection. A bee feeds on nectar and produces honey, in which, I'm told, it's impossible for germs to grow. Some men can use bad art as a fertilizer and transform it into something good and useful, but that is rare. When a question is alive, then the pondering of it can be rewarding. Somehow everything fits together in a useful way, and we can derive some good even from art that is considered to be without merit . . . but to do so requires that I not be caught up in it like a tar baby.

A bit of prose, a painting, a well-made play or an aria can draw me in—captivate my very soul—and I am all the better for it. My hope is aroused and encouraged once again, realizing these things can help in my own pursuits. Books, paintings, music, films, and plays—all these forms—fill a very deep need. They encourage, excite, and embolden a sense for life and move one to consider and to find value in love. Works of art have a capacity to move and influence. We, likewise, influence others with what we receive from it, but we may distort what we receive. It is true as well that when art runs amok it can destroy sensitivity, though it might be difficult to prove this.

There are times, without camera in hand, when the need to make a picture arises. I was very moved at a conference in San Francisco one year, and while driving home this need arose in me. A poem resulted that is related to my photograph, "Empty Cup," taken in 1963. I tried to make a corresponding picture in words. The song arrived as we watched the sea's edge fly by. I asked Jean to write it out for me as we drove:

Coastal Hymn—23 July 1999

Large rocks and stones rise—
Immobile sails thrown into the sea,
Beaten by wave and wind—
Waiting out time, to enter eternity.

Within time we are like empty cups,
Then we're filled with brine,
Teeming with life, wishing for growth.
Residing, but an instant—

One cup full of air,
A breath taken full of life
This one moment, a sail,
Bathing us in eternity.

———

As it is with poems, it is with dreams as well

If I dream of photography, it means I have lacked creative expression during my waking hours. It means I have been lazy and have to shake myself. Likewise, it is true that when friends visit me at night in my dreams, it means I have a need to see them and to talk with them. The more intense the dream the greater is the need. Dreams and poems evoke feelings; a desire to respond can stir dormant forces within and bring more active relationship.

There was a time when I breathed, existed, in a different way. At that time I was cloistered, protected at every turn, but now I am out among others and I need to communicate with all about me. In a dream, I asked a friend what I could trust. He looked at me, simply looked, and I knew it was necessary to think again. In doing so, it occurred to me that where the question came from was the measure of its truth, and therefore its worth. So I said what I thought. He ran to a bookshelf somewhere out of sight and brought back a book of poetry and said, "You need to read this." Such was the intensity of the dream that it kept calling for action and thought, but I was asleep. So I awoke and now find myself before this blank monitor screen writing words. Such

is the nature of dreams. They can be a wake-up call or an opiate to indulge in. If I had seen the name of the book, I would be reading it now instead of writing.

———

Seal Rock

There are pivotal moments when understanding floods the mind like a long-lost brother found in a mirror, a doppelganger, with me standing here staring back dumbly. In my old age, when I saw the Pacific Ocean again, it was like that. I was struck dumb, with a tinge of awe.

It occurred at Seal Rock, near Newport, Oregon. I was able to see there is not only ebb and flow of tide, but wind and gravity that conspire to curl the ocean's tail, creating waves that pound all within reach. Here is an expression of what it means to evolve and evoke deeper thought. The dark rock near the shore was deeply silent within its foam-filled crags; water surged, creating cracks, and booms sounded, while the rock stood firm. The rhythm of the waves was like breathing in and out. Here is a clear example of eternity's expression through time, and at the center is always found a still point. It's what we find at the center of a storm, at the center of a wave, or even at the center of our universe. It serves as a turning point about which all revolves. I have returned to such places many times, as if in a dream. This time the sense of the experience built before me and became an image that was deceptive and trifling. I blushed to think I might have missed its more subtle nature.

This pivotal moment came with the "Seal Rock." It is this picture that also reminds me again of the "Empty Cup," which is all about beginnings and endings. This group of experiences with *image* represents something in my work that began with the 4 X 5 camera and continues even today with my digital camera. Yet, like an unseen seed, it was there in my thirty-five-millimeter work as well. We don't often see or understand as things are happening. The review of images I've presented here has been very useful to me. I have learned along the way. It now becomes a rich impress. My direction has always been with me, even when I walked the streets of Cleveland and New York, photographing people and junk on the ground. My friend Minor White helped the process in his peculiar way. Once I asked him why he would not criticize my work as he did that of his other students, and he said, "You are not my student; we are peers." I have thought hard and long about that statement and see now it meant that we were equally students. It is not to teachers and leaders that we need to look, but to our fellow travelers and peers. So it is necessary to be attentive and alert with this *camera work* that we attempt to do. This can support our looking to the silence in the body and also in the head.

———

A wee bit about two words: Of the two words "why" and "how," it may be that "why" is the more stimulating. That word has such a strong connection with everything in me, bringing strong emotion and an attitude that includes openness toward what I don't know, inside and outside myself, compassion, and the hope to be responsible. With this attitude I might be able to honor my elders and respect them for what they have tried to bring to me—and to many others—over the years. They have helped me to carry on with the work that began with their wish for themselves and for others.

This also relates to my tenure with Minor White and sheds light on the way we worked together.

———

All seems to be a part of seeing, and now I know what can come out of *camera work* and this search. Hopefully, I am not writing this only to myself; this is an attempt to pay back what was given. I once asked Minor, "How will I ever be able to pay for that which I have received?" He responded by saying, "You'll find a way." How misinformed my thinking often has been on this point. It's not a terrible thing; it is just what it is. Knowingly or unknowingly, everyone has helped me in my process of self-discovery. Anyone who can become a student can benefit from working with this as I have.

———

Relating to one's students can be very intense

When I sit in a circle with students I become a student among students, but that is not all. We sit and look at photographs together and an exchange of energies takes place. Each person is a tone or a value, and all the tones are projected across the circle every which way—blending and also meeting resistance. At times in the process a picture is seen that is only understood because we are together. A great canopy seems spread over our ritual circle that keeps us together. In the end, it brings warmth and understanding. The commitment is held symbolically. Sitting like this creates a new entity, an *image*—a helix; the circle does not just go round and round, but grows

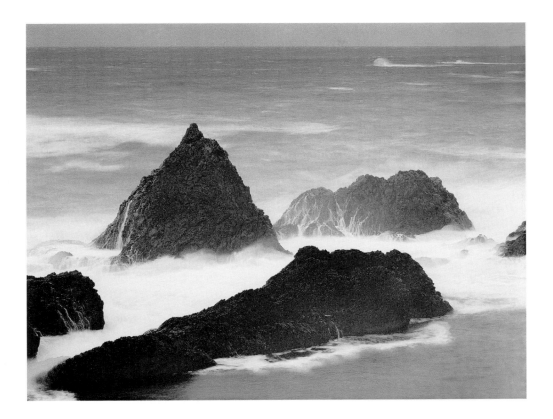

XI - Seal Rock - Oregon - 1987

upward, reaching for new understanding. In this way it is not locked or monotonous.
It can always be opened to include more—even one more student.

Endnote, Chapter V.

1. Patrick O'Brian, *Post Captain* (New York: W. W. Norton, 1995), 349-350, 353.

A LITTLE PERSONAL HISTORY

Scattered images—basic ingredients

One of my early guides in the Gurdjieff Work said, "Nicholas, you are much too impatient and enthusiastic. You remind me of the young archeologist who, upon discovering a city at a dig, rushed to publication only to find out there were at least three more cities buried under that same spot. Of course he only found that out many years later when someone else reported their existence."

In advanced age, I remain enthusiastic, but far more cautious. In this spirit, looking back in time and exploring what can be found, there is a hope of fulfilling my promise—to write about my findings as completely as possible and, in so doing, to look more deeply.

Past, present, and future—together they make a time sandwich. It's this odd configuration that makes my existence. In this particular sandwich is a photographer. All the bits and pieces that have been found are what made me a photographer. To dig enough to find a picture of the whole is desirable; uncovering it might be tough and a bit painful, but it's also useful. Often I have failed to acknowledge influences that have touched me. Here, in this process, I may be able to correct that oversight.

There is a need, in beginning a story, to let go of trying to grasp onto it as personal property. I often protect desires and the things I believe in, but the seeing is the point. My beliefs at times can cause blockages, keeping energy from me and screening out the truth that feeds the creative impulse. That truth can also be found in the criticisms others bring. It takes dedication to work creatively—to keep opening the ground. To receive again and again requires accepting my weaknesses and strengths. As to the rightness of this endeavor—only time will tell.

———

In the past, each day was a lifetime. So here is a place to begin—the spring of my life. In it could be found my alpha and omega—an eternity when imprisoned in school, then a sense of freedom when I was let loose in preferred, lovelier spaces. This experience, and even previous ones found at its base, are the earliest of buried cities, which bring rich impressions. These are the keys I found, tools to free myself, but at the same time I have stumbled upon obstacles as well. Finding freedom hinges upon all these things.

Among my earliest memories is watching my dad tie his necktie—what a wonder that was. How did he do it? Another early memory is the sight of my mother putting white polish on my shoes and laces, then laying them out on newspapers—the glow of little shoes and laces drying in the sunlight . . . the sun streaming in the window and me on the floor, watching all this and smelling the white shoe polish.

The most distressing memory from this period of my life, which makes me cringe even now, was trying to take a little self-propelled car from another little boy when I was two. Ranting and raving, in a tantrum, I thought it should be mine because I liked it. Coupled with this memory are two other impressions. One was observing people talk; they did not seem to make much sense to me. And the other was hearing people sing. Of the two, I preferred the singing. At times I wonder if I thought that my anger and crying about the self-propelled car was a kind of singing. Ah, perhaps this was simply the beginning of my personality getting in the way.

———

Games played and deceptions

It was April and very near that time I called *freedom*—summer, to be exact. My dad was sitting in the kitchen and I was leaning against his arm, watching water come to a boil on the stove. The 1936 Johnstown flood was the biggest flood ever, and we had to boil water before using it. My dad was smoking his pipe, and I was amusing myself trying to catch the smoke rings he was blowing. There was no electricity and it was the burners on the wall that gave illumination. When Dad had tested them we were sur-prised they still worked. It was still the dark part of the morning and light was needed,

and this golden gaslight filled the room. Dad asked, "Do you want to smoke my pipe?" He offered it and I took a puff and went into a coughing fit; it was awful. Smiling, he said, "It might be better if you didn't smoke." Then he looked out the window intently at something. After a time he said excitedly, "Look, look! There's a rabbit in the yard!" I leaped toward the window only to discover that there was no rabbit. My dad laughed, "I made you look, I made you look, to buy a penny book." I don't know if it was actually April first, but he played the trick anyway. Some experiences of childhood blissfully never vanish.

————

Why ask someone to look when there is nothing to see? Of course I know now that people play jokes on others at times to feel superior; surely there is more hidden here. My father loved me dearly as a child, so for the moment all I can do is look at his antics as games; perhaps along the way some further insight will arrive. For now I'll leave it.

The incident of the rabbit happened at Paddy Leonard's home, where we rented the second floor. Moments of awareness like these are scattered throughout my life, surrounded by voids as to what happened before or after. Consciousness had a way of turning off and on without warning at that age. Is it any different for us as adults? I wonder.

————

Many lessons came to me when I was quite young that later had significance. I had learned something very important from Paddy Leonard, who was justly upset with my

constant stomping about on the second floor and down the stairwell—disturbing his flute playing. Paddy was a staunch whiskey-drinking Irishman. One day he made a wager with me about sitting still for two minutes and said he would pay a penny if I could. I perched on his big leather couch, legs dangling—watching, listening to the tick-tock of his institutional clock on the wall for all of two minutes . . . it was painful. The moment the time was up I grabbed the penny and ran out of the room in a commotion, eager to spend my prize. The image remains of the clock ticking and that leather couch; they still exist in my mind and heart, but what was bought with the penny is lost amid the ashes of time. Dear Paddy, whatever happened to you? I don't know, but I hope you found peace to play your flute.

I see at times that the world is in a great hurry, and it seems sure proof that there is need to slow down. How can we wait for the right moment to make a decision? In that moment of waiting, is it the stillness that helps? When I was experimenting with becoming quiet in order to make a photographic exposure, Paddy Leonard entered my dream-filled mind, along with an impulse to bow to this rogue whom I encountered when I was eight or nine. I am deeply indebted to him, even to this day.

We were still passing through the Depression; many tasks and new experiences awaited me. Mrs. Leonard, who was like a grandmother to me, introduced me to several things: chocolate and rhubarb pies among them—and fresh pineapple. I asked her how pineapples grew as she was cutting the top off of one, and she told me that all we had to do was place this green top, with its little underside of lemon-orange, out in the flower garden and a new one would grow. Walking out to the garden with me, this is exactly what she did; she spat on its lemon-orange bottom and placed it ceremoniously among the flowers, saying that I should take care of it. I spent all that summer

watering and waiting for the pineapples to grow, but all that happened is that the green top turned brown, and the lemon-orange part of it shriveled. Finally I lifted it to see if there were any roots—of course there were none. For me there seemed to be a value in hope, but as my Aunt Irene used to say, "Spit in one hand—wish in the other, and see which you get first."

––––––

More from youth

I was not bogged down with a lifetime of the opinions of others when young, nor with deeply entrenched attitudes that got in my way. There was a sense of freedom, and impressions were fresh and plentiful. Images were everywhere; they were a food that fed me. Experiencing life in childhood had a most profound effect. Here are a few more shovels full from my diggings. They took place at my Great-Aunt Emma's country home, during the Great Depression. I was lucky enough to spend my summers there between the ages of six and nine.

One day, late in summer, my aunt said "Your mother and father are coming to see us today." I had not seen them for some time, and was I excited. Here in the country we lived on a lonely road with a little hill in front of the house, and I decided I would wait for them there on the hill, as I would be able to see them before they could see me. I sat cross-legged in the grass upon the hill and waited. A great deal of time went by, and I eventually began to hear the wind as I strained to hear the car or see it; no car came. I could hear the bees in the clover all around me, going from flower to flower; seeing the grasses touching as the bees alighted brought me such stillness.

Suddenly the afternoon was ended; my parents never did come. I don't remember being disappointed, but I do remember the smell of it all and the images. I spent many afternoons like this one, catching bees by the wings and daydreaming by pools along the stream. I wonder why we call these experiences daydreaming. Dreams we forget, but it is not so with these realities.

———

There were strawberries in random patches alongside the big house, and under the house was a spring cellar with spring water running through it. In here were kept all kinds of things, like milk, cheese, butter, eggs and vegetables—things that needed to stay cool.

I was in the yard picking and eating strawberries one summer day. The day was getting hotter and hotter. This prompted me to go into the spring cellar to be cool, and there I sat and continued to eat my strawberries. It was quiet here, with only the sound of the running water and the drip-dripping of the cottage cheeses that were hung in cheesecloth wrappings over the water. There were thin cracks in the door between the boards that let in light. Fascinated with this, I watched as the stripes moved ever so slowly; other than this play, all was quite dark. I still remember this happiness and stillness. It was as if my total world was contained there within it. Somehow, images of grasses were on the wall of the spring cellar, and they moved as the strips moved—how strange.

———

I had many duties given me when I was staying in the country. There was the job collecting the eggs from the hen house. The first time was a disaster, however, because I brought in the porcelain eggs by mistake. They were in the nests to encourage the chickens to use the nests, instead of laying eggs all over the yard. My dear aunt laughed and laughed as I tried to discern the difference between the real and the artificial. My logic was that some eggs were simply heavier than others.

I was better at other things, like going up to Indian Spring to fetch water, even though it was more ritual than a necessity. I had a long pole to which I attached half-gallon bottles, one at each end. The half-gallon jugs had an ear on them; twine was passed through the ear and then wrapped tightly about the pole at each end. It was a long trip along the ravine to the spring, and I followed the path with this contraption balanced precariously atop my shoulders. It was a quiet walk, and I found myself always listening to the birds, the wind rustling the trees, or a branch softly falling from them. Here I was up among the tops of the trees, whose roots were deep in the ravine, balancing my two jars. I rested at "Half-Point" after a long haul, with legs, arms, and my whole body aglow from the effort. As I was sitting in this way on a bench of logs along the path, all my questions—childhood questions—came flooding over me. As I sat longer, the silence returned. Birdsong, wind, then silence, and all beautiful. In a short while, in the distance I could hear a dog barking, and all I could do was smile. Time and something else—not-time-at-all—were blending.

————

I arrived very late at my aunt's house with my parents. Aunt Emma did not expect me and did not have my place ready in the little house where the kitchen was. So they

took me to the big house to sleep. It was a winding path to the big house, and we walked in the night with our kerosene lamps. I loved the smell of the kerosene lamp burning and watching the flickering of its flame. This big house did not seem to be quite built, though it was completely enclosed. I remember lying on a narrow bed against the wall, and above, lit by the moon, was pinned a rattlesnake skin. I was filled with awe—or was it simply fascination and fear?

––––––

What is it about our experiences of awe?

What is the source of the human experience we refer to as awe? From what does it arise? There is a dictionary definition, but what do I know about it—as an experience? The dictionary says it's a mixed feeling of reverence, fear, and wonder. But knowing that is not enough, because it is the experience of it that gives it substance and meaning. To see, actually see, an infant's hand moving and alive—to sense that mysterious force that moves it, and also moves me—is to see my vulnerability and to respect existence. These experiences remind me of other, earlier encounters with awe. I did not call it awe, however. It was simply a feeling of wonder.

––––––

When I was growing up it was part of our tradition for the parents—and the adults in general—to decorate and make ready the living room for Christmas. The children were not allowed in, and the grand sliding doors were closed. We were left all day long to imagine what was going on in that mysterious realm—the living room. They even

made sure we didn't see when the tree was taken in. The room was opened finally; at midnight we were allowed to see all this glory. It was then that we were permitted to open our presents. Christmas Eve was a magical event. I would stand transfixed, looking at the tree stretching to the ceiling with flashing lights and tinsel glistening in darkness. With presents in the offing, these moments were short-lived, and soon the paper began to fly with the unwrapping of gifts. I felt that grownups lived in a mysterious, wonderful world, and I wanted in. Even with all this joy, we found in the morning that our socks were filled with little candies and tangerines.

———

To be human is a wondrous thing—a light going on in the darkness. When this light goes off, we do not receive all that is possible. There is a need to return again and again to this experience. Looking back through a lifetime, it can be seen that these islands—these isolated experiences—are sprinkled over large voids of sea. Seas can rage, or be calm as a flat table mesa, with no wind at all. Though wind howls or sun shimmers, the small islands are havens in between. Such are these experiences of reverence, of being a part of something greater. Am I a part of a greater world, or too insignificant to even matter in this larger scheme? This thought again brings me into question, and with it comes wonder. Without awe, we cannot truly be alive. To have this revelation is human; it is a threefold gift: fear brings intensity to my wish to be, wonder brings a never-ending flow of questioning, and reverence brings respect. Of course, I cannot say I want an experience of awe and have it appear magically.

———

Faith, hope and a taste of the unknown

Let me take a great leap into the future with an adult experience shared with my wife. There was a trip Jean and I made to the Library of Congress in Washington, DC—a pilgrimage—and of course it was spring:

It was a bright weekend in the late fifties. We stayed at a friend's house in Arlington, Virginia. This friend had already supposedly set up a meeting with a curator at the Library. We had for a long time wanted to see the Library's collection of Stieglitz photographs and were filled with anticipation. The curator almost did not let us in to see the prints because they were in storage, but when she learned we had traveled such a long way from Cleveland and saw I was a young and enthusiastic photographer, she finally relented. All things worthwhile seem to meet with resistance. Finally we were sitting in the storage room looking at these beautiful gems created by Alfred Stieglitz. The reproductions of these images found in a book are not like the originals. In no way did my previous experiences hint at what we were finding now. As we looked, all physical tensions slowly drained away from me without my noticing. I felt a profound peace. The images seemed to bring energy, and we looked at them all morning long. We were experiencing a journey as two children might, with a sense of wonder at every step. These beautiful flowers, trees, and clouds: not just photographs, but real works of art—poems by a master.

After two hours of looking at Stieglitz's images, we walked out of the Library full of energy, feeling so light. I said to Jean, "I feel like I am walking on eggs. I need to be very careful so as not to break any." Outdoors it was beautiful, and everything took on renewed significance as we moved in a fresh way—taking in impressions of the day as

if for the first time: experiencing direct contact with the world around us, while at the same time this sense of "I am" was included. It was a momentary instance of being complete, a quick taste of what we could be as humans—a moment of belonging, engaged in a process called *now*. This nature calls me again and again to itself, to this state wherein something is alive and vibrates. This was a gift from a master—though he had passed on many years before—to potential students who made the effort to be with his *images*.

———

To exist meaningfully

Each person I have known has a place—a special place—that reminds me of that person and no other. With my mother it is the summer and the kitchen, in our home in the early forties. Sitting in the kitchen with the venetian blinds pulled to keep down the rising heat. We spoke often about feelings, wishes in our lives, and how we might fulfill them. Slats of light like lines of truth filtered into the kitchen. The room was transformed in those moments, and all that was said there was considered sacred. In those days I thought I was an artist and wanted so much to be a good painter, someone of value. My mother was always sorry that I had never become a musician, but fate was not with her; it was simply not my destiny. She even joshed with me that I sounded more like a preacher than anything else. However, her love for me was undying, and she constantly encouraged me to the greatest of heights. So it was that I always considered that I must be somebody rather than nobody, in spite of the lack of much tangible evidence. My mother was seventeen when I was born, and we were more like brother and sister than mother and son. We were great buddies. When I

strive to accomplish something, even now as an old man, I think of her with tenderness. Love seems to have been an important key to perseverance, and no doubt a certain amount of blind faith.

———

One more bit before leaving childhood

My mother cared for me deeply. We were constant companions. She was indeed like an older sister. When I was a two-year-old we polished our white shoes together, and she read the funnies to me each Sunday morning. We would tuck ourselves up into the large bed under a big fluffy feather tick, cozily, and read "The Captain and the Kids." My most precious moments in early childhood were always with the ladies of the family—my mother, my aunts, cousins who babysat, and last, but by all means not least, my grandmother. I was her only grandchild for twenty-two years, and as such was cherished greatly. *Nicky could do nothing wrong* was her constant tune, and all was met with a big smile and a hug, however wrong I was.

As I grew older my uncles figured into my life more and more, and life became complicated. With them I had to hold up my end and not dawdle along the way when we were off exploring. Not everything I did was considered cute.

My Uncle Dan coaxed me into biting into a long hot yellow pepper from the garden—saying it was a banana. My, how I cried. After that I never quite trusted him. From then on there was—and has continued to be—an element of doubt with adults—with big people in general. Looking more closely, though, I can see that everything and

everyone is a mixture. This mixture brings all the possibilities of joy and sorrow with it in some stubborn way.

Looking back into past experience informs me regarding why I am here at present, and the present can inform me about where I am going. Adventure and misadventure help me to see how I came to be a person who searches for images, trying to pass on whatever I have found through *camera work*.

I realize that some may think all of life is only repetition. I think that anything worth saying is worth saying a thousand times, and in as many different ways as can be found. But at the end of the day, only flesh-and-bones experience will do. It is true that in the child can be found the man. In reflecting on my own childhood, I see evidence of the adult I have become. And in observing children of today, one can at times see the adults of tomorrow.

Learning to swim beyond our depth is essential. There is a need to encourage an appreciation for adventure, experiencing again and again a respect for small mysteries and small miracles encountered along the way. When I engage in living in usual ordinary ways there is little possibility of being taken away from my complacency. Experiences where I am at risk penetrate my defenses, and I am freed. It is difficult to comprehend, but it is the way I am fed and nourished. It prepares me for the possibility of the greatest awe of all—which is the realization that *I do exist*. Awe brings life to what otherwise is meaningless, without being—empty.

———

Again creative audience

There are two definitions for the word "audience" found in the dictionary: paying attention, and the act or state of hearing. This is not something passive—being a passive audience—but rather something very active. Through intentional deeds we could be creative. To be an audience—even an audience of one—is to be activated and moved, not just reactive. In addition, it requires making use of our ability, without being caught in our judgments. With judgment, everything stops; the possibility of exchange slips away. So with a *creative audience* comes new possibilities; here we can find a real intention to exchange with each other.

It takes energy to make energy, and without more energy than we usually have we cannot see beyond our noses. Fresh experiences like those that come to us when we travel enliven us, but one cannot always travel. When we are in strange, new places there is a demand put upon us to bring attention to what we are doing; because of this our experiences are heightened. What seems to be a part of it is a measure of intention. Efforts made with intention bring fresh impressions. To go beyond my usual limit is important, but it is not enough.

Working with others also can help me go beyond what I take to be my limits. This is where *creative audience* is useful. It is a way—one of many—to attract energy and insight. We pay with our attention and intention in order to receive fresh impressions—this is food. With *creative audience*, exchange becomes a pathway.

When someone presents a photograph, a poem, any work of art, it becomes useful for me to be still, to gather energy and be open, working quite actively. All this is

necessary in order to be receptive, so that our exchange might be fulfilling. We all feed on each other, and when we return to the field to photograph, all will be again renewed. I need to find fresh pathways in my relationships to people and in nature. In this way I even strengthen the responsibility for being an audience of one. It does not just happen; it is an ability that has to be learned with some considerable effort. It is possible to respond to any image and to the world in a creative way—not to just react!

MANY CHOICES . . . MANY JOYS

Childhood dreams and the creative force

In childhood I wanted to be an artist. I was told that being an artist had something to do with living in a garret and sleeping with models. This was a very exciting prospect: sleeping with flowers and vases, lemons, plums, apples and the like was my bailiwick at that age. I never attained better than that, even as an adult. There was attainment of something, however—a small insight as to what it might mean to be an artist. There is a certain joy in that; this does actually belong to me. I have pursued this interest of mine not only with camera but also with poetry, teaching, and even being a museum photographer. Also, there were the attempts to paint on canvas, and make pots. And I built a house with my own hands. I began doing all these things knowing very little, and with much surprise I discovered that by pursuing something seriously we begin to know less and less, rather than more and more. It was tricky to keep with it. Working

is not easy unless you realize that it is worthwhile, in the end of ends, to know less and less. It brings me face to face with the *creative*. I am a photographer but that is not all. I am not a writer but words appear on the pages nonetheless. So what can be believed?

Photography . . . its difficulties and possibilities

Roaming the mean streets of Cleveland when I was twenty-five was the beginning of my photographic career. Here I watched the poor who lived in a city within the city. This was a foreboding place to me. People were my first subjects, photographing them in their neighborhoods. Then later on in Amish country children were my interest. The child within myself can be present when I see life being enjoyed by children. Children always want to have their picture taken. They are the most vital and open. Perhaps some grownups can still be comfortable in front of the lens, but they are harder to find. Adults for the most part do not like being watched—they are filled with inner concerns about being judged.

Then there were the discarded dolls, broken toys, dead things, and piles of all manner of refuse that the camera was turned on. All these things carried an aura of *art* for me. The sordid side of things became fascinating. The camera was turned on derelicts, drug addicts, and street people, those we think to be the failures within our society. They have been left behind and suffer greatly. There were cases when I was chased and cursed as an intruder when I took their pictures. It was a just reward for intruding, for who am I to judge?

There was an insistence on my part, even though I saw that their world was being invaded. Can anyone attach blame? They are victims, and I did not see for many years

how inconsiderate this activity of mine actually was. These exposures were seeds; they were mirrors of a growing, festering realization, as they became my looking glass. It was myself—me—I was seeing.

———

I took pleasure in my pictures, but after a while it became apparent that all seemed not well. Somehow things were not quite right. With all my work, uneasiness was growing about my picture-taking. It was not just a question of technique. The pictures seemed not to stand on their own two feet; they didn't have two feet, four, or even any feet. So I began to experiment, to eliminate a little here or there, removing the parts I disliked. From this began a new series of questions, and then newer ways of lying to myself. A refusal to accept the looking glass—that I was photographing myself.

This self-deceit became the norm. My photographing was imagined, as looking into a mirror. Where then can trust be placed? In some strange, fascinating way, the images became a record of a descent into a world of false *creative imagination*. All this was a place where the image became nothing but the spinning of one lie after another. There had to be a way of getting beyond this veil of imagination—which was a personal hell. Where, then, could the truth be found? I was being acknowledged and given prizes for these images in one show after another. This did not help the problem. At the time, I did see these images as missing the mark. A question arises for me when looking at them even today. How great does the lie need to be before conscience is aroused, or does the lie tranquilize us? It is interesting to see that my liking and disliking equally seduce me. And why was it liked yesterday and not liked today? Should my nature be consistent? In this way, another obstacle was reached—that of actually seeing the

image as a mirror of my own sense of perfection and imperfection, and that brought painful results. Conscience does have its sting.

More and more photographs of these so-called imperfections were then made—only this time I watched them more closely, and to a degree began to accept some of them. They were what they were, and me here seeing could bring a sort of balance—when I was there seeing, a balance seemed to appear. With this came a small sense of completion; there seemed many stages.

We all wish to express our feelings, thoughts, and ideas. Seldom do we take into consideration that through the attempt to express them our views change—and along with this comes the possibility of the inner awakening of conscience. Nor do we realize, until we experience it to be so, that a love-hate relationship arises in working with passion. Without this love-hate—or, said another way, without resistance—there can be no movement of any kind toward being enlivened. There are more questions that can arise: Can I see all this in action, for myself? Is it all a part of being exposed to my muse?

When craft is a means of self-inquiry, and particularly when the body is included, a metaphor can be realized. A relationship with the outer world can be cultivated through empathy—to become a tree, a twig, or a stone on the ground. In the early years I did not actually realize that this was what I was experiencing as I worked. Nevertheless, through this activity I experienced that I am—in part—the earth. In becoming a part of the earth, I became the metaphor. There was this unusual sense of belonging, of not being left out. With each experience of *image*, seeing that the image is potently myself, there is the wish to return again and again to source. With pictures I can be in touch with that timeless realm—connected to a world of mystery, with me

as an active participant. With the two Amish boys that I photographed I realized this for a moment.

———

Others as mirrors and the mirage of justice

These observations about nature are also applicable in other situations we find ourselves in. For example: Think of the news video image, taken during the Vietnam War, of a little girl naked in the middle of a war-torn road, her arms outstretched, crying. She is, for me, like Christ sacrificed, and I question—for what? There is another image—again of a child being held in its mother's arms—which is among the photographs that Eugene Smith took of the victims at Minimata who had been poisoned—the result of industrial dumping of mercury into Minimata Bay. The child is like Michelangelo's *Pietà*—Christ actually sacrificed. Both images call out to us. Somehow our ability to empathize is enabled by people who show the truth vividly and with compassion. The result for the artist and the public alike is palpable—a vivid shock. Healing surely comes with this awakening of conscience. But often it is misunderstood, and we take up righteous martyrdom—as though it were truly useful.

Our justice is a frustrated attempt to bring peace and sanity, but it is not able to achieve what only conscience can. Objectively, justice can only be activated through awakening. As things now stand, we punish perpetrators of wrongdoing. Some people see this as valid retribution. It is no substitute for right action. Real justice opens us consciously to healing rather than being a form of revenge, as is now the case. Surely change is needed, but what is the fundamental nature of change? Can it be weighed,

measured, codified or seen in ordinary terms or as an expression of man-made laws? As things stand in the long term, but also in the short haul, the human things, the things that really count, don't change.

There are attempts to bring methods leading to favorable outcomes, but it cannot be forced, and it will always be about balance. Looking at Kosovo, we can see a good example of the principle that you can lead a horse to water but you can't make him drink. There is a poison deep within the soul of man connected with his desire for the survival of kith and kin, as well as with ego and self-pride. There is deep confusion between personality and a natural essential need for survival among human beings.

We are all victims. There are always invented reasons coming from the ego for every action. What's the difference whether we call it reason or responsibility? There are codes we create, and we even learn to live by those codes. More important than reason and codes is *conscience*, which we see expressed in the two photographs mentioned above. We have a conscience, or at least we profess to, but actually there is a need to search for it, as it is deeply, completely buried. The river of self-deception runs deeply; our codes and what we call our *ethics* constantly deceive this universal conscience. There must be a way that leaves open a point of view, held within the heart, which goes beyond self-delusion.

There seems not to be a present-tense way of expressing it, except to say there is a need to sense *being*, which sounds like a commandment of sorts. That might not bring help. Perhaps "I am" would be a way out of the dilemma, but when I say "I am" it is usually a lie. How then can one get the taint of the lie—deeply ingrained—out of saying, simply, "I am"? Will it matter when we are nothing but ashes? We cannot even

imagine ourselves as ashes. Along with the physical ashes in my case will be heaps and piles of words and photographs. I wonder if anyone will sift through these looking for answers. In a way, I hope not, unless those ashes become mirrors for them.

––––––––

An effort to be open and giving

I never had the intention of teaching photography, certainly not on a college level. By 1963, I had bought my first large-format camera, and was only then thinking how to make a living with photography. This came to fruition when I was hired as an assistant to the photography department head at the Cleveland Museum of Art, in December 1967.

Soon after I started with the museum, Case Western Reserve University had decided to experiment with Inter-Session classes. These classes were to begin in January 1970. The classes were made available to students who did not take a break to go home between semesters. .A student working in the Architecture Department office had heard of me, and suggested that I might be an appropriate person to teach Inter-Session classes. The Department contacted me and this marked the beginning of my being a teacher.

I had great doubt about being able to teach, as I had no formal training. The question arose: Why teach? There was fear of even trying. True, I was responsible for the Minor White Cleveland Workshops at that time, but I could run to Minor when I needed help. Finally, I talked to an older friend, Larry Morris, who was retired from the

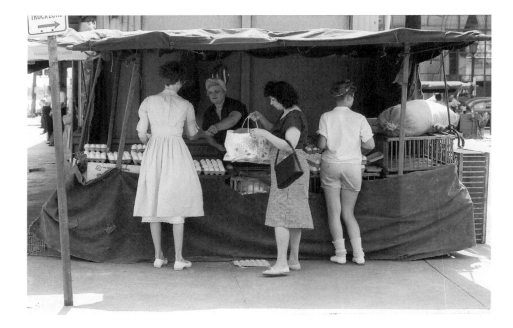

XII - Egg Lady W. 25th Market - Cleveland, Ohio - 1950s

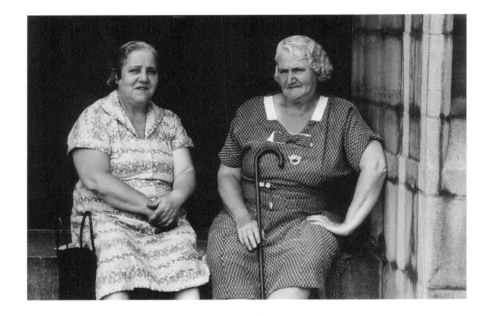

XIII - Two Ladies of Verona - Cleveland, Ohio - 1950s

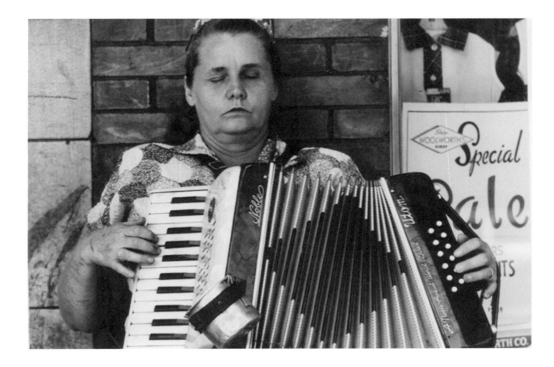

XIV - Blind Lady - Cleveland, Ohio - 1950s

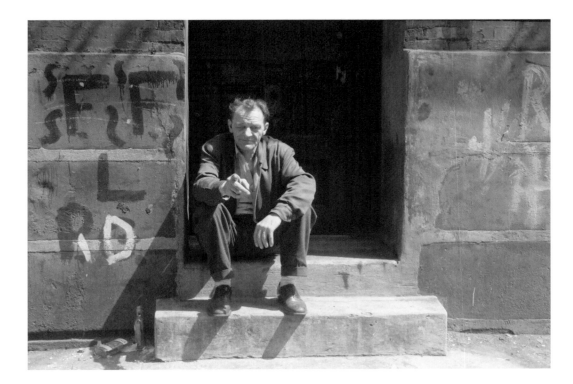

XV - "You" - New York City - 1950s

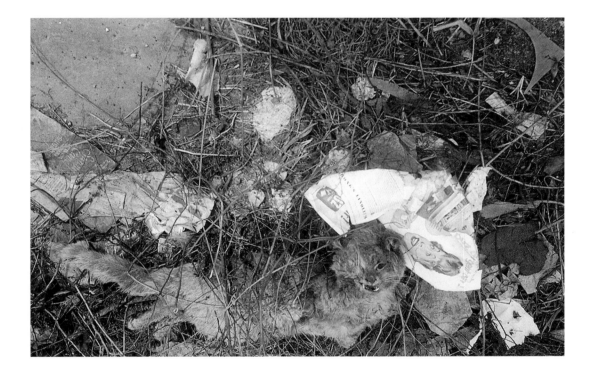

XVI - Dead Cat - Cleveland, Ohio - 1950s

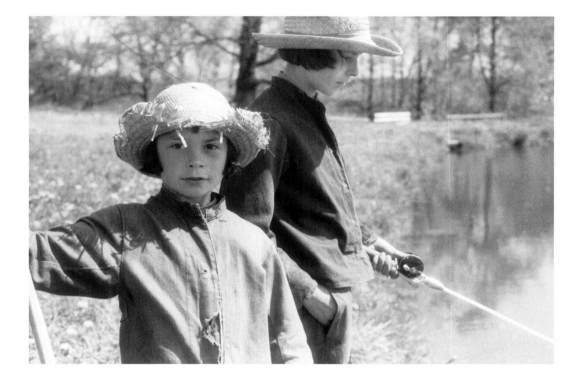

XVII - Amish Boys - Millersburg, Ohio - 1956

Diplomatic Service and had been stationed in the Near East. He was a fine man, and I respected his understanding highly. His only question was, "Did they ask you or did you ask them? If they asked you, then why not find a way to do it? After all, it's likely that what you could bring would be more interesting than what many others would bring." He pointed out it would be of great benefit for me. A proof to oneself and others that we actually know something is the ability to teach it to another. The real key was that to be a good teacher I actually had to become a student. One thing Minor White said in connection with all this was that, in his experience, when teaching went right, he could sit back and watch it happen.

I went to my first class with great concern, not having the least idea of what might happen. Here were twelve new students looking to me—for what? How to photograph? They already knew how to make pictures; they were not new to the craft. But could I be helpful to their needs? Neither they nor I knew what they wanted. These questions would have to be put to them, as well as to myself, in a fresh way. All was in motion, and with this spinning and indecision came a sense of vertigo.

To begin with, I told them a little about myself—that they could call me Nick, not Professor—and then I wrote my age on the right-hand side of the blackboard. I told them straight out about the questions that were of interest to me, and told them I wanted to know theirs. This sounds indirect, but I was truly interested in some way of serving their needs. No one reacted, but they simply responded when questioned. In speaking to these questions, each student also gave his or her age, as I had requested, and the ages were listed in a long column on the left side of the blackboard with the names. Their ages added up to over two hundred and twenty-five, and my age was only forty-two. Turning from the blackboard, I said, "It seems I will learn more from

you than you will from me." This delighted them, and with that one stroke, tension was released from the room. We were off to a good beginning.

Most of my students wanted to exchange ideas; they were interested in exploring the experiences they had in the process of photographing rather than the techniques. This encouraged me because I secretly wanted to explore aspects of creative experience. There were no darkroom facilities of any quality on campus anyway. So that is how I began to guide students along the path of photography. In the beginning, we ignored the darkrooms and worked with Polaroid. When questions did come up about techniques, we naturally explored them, but for the moment we had a different aim. The point is that we had experimental techniques for creative experience and even took some of those techniques into the darkroom to apply there. I wanted them to know that it was inner development that made one a photographer rather than a development of the use of techniques in the media.

Inter-Session classes were held for a few years and then abandoned. The Department head wanted a year-round evening class in Creative Photography to be taught, as he felt the influence I brought was useful for architecture students. From all this came much that was good for my work and for the students. My working with students has always been based on the needs they expressed. In general, it was their personal experiences in the media that interested them. To clearly convey what they wanted, such as personal feelings, they needed to know the basics, and we did include them. Mainly they were excited with my questions: What is creative photography and why do we photograph? Am I the photographs I take? This process delighted all of us.

Material brought to teaching sessions and challenge

The notion that questions lead to more questioning brought life and progressive movement to my classes. When we worked in-group as we did, it became apparent that much more could be learned. Students were encouraged to show each other what they knew, to learn by showing others. We began to see that to be able to express ourselves it is necessary to sensitize our bodies, and to enrich the mind and feelings by reading various books. We worked with exercises from Gestalt psychology. I borrowed from everywhere what might be useful. This journey began to be a real joy for me. My own work and the photographs of others were brought in for critiquing. And bit by bit an approach was built. We gathered personal experiences, reading lists, images, and took field trips together—a great cornucopia of exploration.

In an evening of experimenting with blind walks followed by a discussion, many students were amazed that we can actually see with our flesh and bones. They worked in pairs and then exchanged roles, first following and then leading. They experienced the distances between themselves and the walls—noticing temperature changes from one part of the room to another and seeing that they really could trust an external guide under controlled, more or less sane conditions in class. Although they did not bow to one another, their gratitude was obvious. This was a small taste of trust in one another. It was gratifying to see that the blind-walk experience was so fresh, vivifying, and worthwhile for all.

Thankfully, there were students who challenged me. In those days there was a pervasive suspicion of anyone over thirty-five. When a student told me this one evening I replied that I was very happy to see that he had this point of view, because it meant it

was necessary for him to become a better guide than myself. My reason was that at his tender age he was already sensitive to truth. I was in favor of his honest, enthusiastic nature and asked him to remind me when I fell short of the mark. I do not know where this response came from in me, but it did help.

There was a problem in those days, as students were experimenting with drugs. I was concerned about their coming to class under the influence, as it interfered with what we were exploring. It came to me one evening to say, "God does make his own. When we are lazy, we dream—our class is not the place for that. Working with attention can show the truth of what I say, but there must be work to find out." Surprisingly, the students did not walk out on me, nor did those few who were on cannabis come to class under its influence again. I was pretty good at seeing when they were using drugs. At that time I taught them some simple principles connected with meditation, which gave them more solid experiences than drugs.

———

Questioning the experiences of creativity

Later in the school term—Monday night session—we were sitting in a circle. There was a very quiet atmosphere, opening with these questions: What is creative photography? What have you learned with regard to this question? What can you say based on your experience? Some of the answers were most amazing.

> *Creative is something I experience in a state of relative awareness.*
> *Creative is something I can be a part of when I am present.*
> *It is not so much that I can be creative but am open to re-create.*

Another question: *Can an animal be creative?*

My response: No, I don't believe so. Only human beings can take a thing and help refine it into a finer materiality through the gift of intention and attention. By this action we play a role of that which is higher than what we are working with. Raw clay is one level of materiality, but if I form it into a bowl, glaze it, and fire it—what is that? Is that not a finer form of materiality? It seems to me that creativity relates to a special force within, a movement that can act in me or through me at moments when I am available. After all, the question might as well be: Do animals have conscience and consciousness? By no means do I see animals pondering a question of the day with attention or intention, as we have come to understand these terms. Nor do they act with mind, body and heart, lacking the human intellect.

Student: *Is not this force like light passing through a prism? Will it not give the same results regardless of the prism it encounters?*

Response: I like your analogy, but think of our crystal or prism as being organic, as we are, rather than inorganic, as prisms and crystals are in the rest of nature. Imagine, if you will for the moment, that this light or force acts upon an imperfect organic prism and has a miraculous ability to correct and perfect this prism's ability to transmit more clearly. I believe this relates to ways of inner growth. I'm not altogether sure, but it does give me a ray of hope. What do you think? Also, we are speaking of an intentional extension of evolution that expands, and gives us responsibility. We are not only animals.

Do you see what this student's concern is? This is a question for me even now. I am in agreement when I bring mind, and body, to the question—with this action comes the notion that it is a higher force that then includes my feelings. The laws of nature were not intended to obstruct us but rather to help us if we wish to be helped. The recognition of truth tends to correct my organs of perception—this crystal that presently, at best, is quite faulty. I always try to encourage my students to be hopeful and to work—what exact notion of hope I am never quite sure, but this is the best I can offer them. As I have said before, we are potentially human beings. There is an aspect of my nature that values and responds to metaphor. If you do not connect, what more can be said?

It is a paradox, isn't it? We are all beggars, and at the same time something is expected of us. Somehow the *seer* in us demands that. When I talk about art, I am talking about the action of the *seer* in us. It is that "something" in us that knows what to do. People in general think they know what art is. It is a word that has become fixed in their habits in such a way that nothing fresh happens—no new breath of air. After all is said and done, there is no help to be found if we are not in question. When the glass is full, nothing can be added. Perhaps I need to remind myself again and again.

————

It was an inspiration, born of the moment, that bade me take Minor White's first sequence, *Song without Words,* to class one evening. We sat on the floor, which was usual for us, to look at his sequence. Fifteen people sitting cross-legged in a circle, waiting patiently to look at pictures. I started the sequence off to my right, a print at a time, and as each photograph moved around the circle to those waiting, I could feel

a force being generated. How cautiously and carefully they passed the prints. As they looked, I watched them. When the person to my right had finished the sequence, I put my right hand on his left shoulder, and this gesture continued with each person around the circle. Our side of the circle waited patiently while others finished. At the end of the viewing, right and left arms became outstretched over each other's shoulders, and something in me said out loud, "That's another meaning of a circle." Then silence for a while, and smiles appeared.

———

I am reminded of something I've just read in Patrick O'Brian's *Testimonies*, for silences in my classes were dearly cherished—indeed, as much cherished as true and simple words:

> I do not recall what we talked about: it was very small talk, probably, but it was easy, unembarrassed and free. There was no sort of effort in talking to her. If we fell silent it was not that either was searching for something to say, it was just calm silence as companionable as talk. She had a rare gift for silence. How rare it is. I read somewhere that music is made up of notes and the silence in between: the one as important as the other. It certainly holds good for talk.[1]

———

I am grateful to my students

Over the years we had many weekend workshops in photography. The University had a farm east of Cleveland, and there was a small meetinghouse there called The Pink Pig. It had a kitchen and a second-story loft, and a huge beautiful fireplace; it was spacious. The place was ours for the asking, so once a year a number of students would gather those interested and ask me to conduct a private workshop. We would descend on The Pink Pig on Friday evening and stay till late afternoon on Sunday. Nothing but photography and things related to photography took place for this whole time.

I put a lot of weight on the need to know many things. If we are to engage in creative work it is necessary to know something about psychology, philosophy, poetry, history, even religion, and to explore in general. Writing and conversation were very much encouraged. Just to make images was not enough, and most important of all was to learn that we could be responsible for what is brought into being. "Know thyself" became a helpful key. I would research themes and pursue material from books that held my interest to share with them, and poetry, which was very effective in setting a mood. We built reading lists together, and one list of books I used over and over again for such weekends was:

Basho, *The Narrow Road to the Deep North*
Albert Einstein, *Ideas and Opinions*
Eugene Herrigel, *Zen in the Art of Archery*
René Daumal, *Mount Analogue*
A Night of Serious Drinking
Rainer Maria Rilke, *The Sonnets to Orpheus*
Letters to a Young Poet

Richard Boleslavsky, *Acting: The First Six Lessons*
ee cummings, *i, Six Nonlectures*
Loren Eiseley, *The Unexpected Universe*
The Night Country
Carlos Castaneda — His first four books, which I feel are his best
And, of course, *The Art Spirit*, by Robert Henri

We made our own meals together, drank together, and talked only about things related to photography—it was a "wall-to-wall" use of our time. It was a retreat from outside life, being isolated this way. This was a *ritual stage* where much could be experienced. In a sense, we were fenced in. There were some very intense moments, and from what I could see, most students had great joy from these workshops.

———

Later, in the 1980s, there were workshops held at my cottage along the Allegheny River. On weekends we became a separate reality, cut off from the rest of the world, attempting to find renewal. Some of the themes we used in searching for images were Magic, Alchemy, Poetry, and Nature, to name a few. I am deeply grateful to all my students, for without them I've no idea where I would be now. This extended family brought happiness and opened many horizons; it is an important, vital part of my life, and a more real education than anything I had learned in my formal education. For all this experience I feel indebted. I wonder if my debt will ever be repaid in full.

Endnote, Chapter VII.
1. Patrick O'Brian, *Testimonies* (New York: W. W. Norton, 1995), 137.

Journeys . . . Inner and Outer

More years and discoveries

In the early days I would travel to Minor White's house once a month. He lived in Rochester, New York, at the time. We would spend hours looking at photography and talking. One weekend he had me do the layout for the Imogen Cunningham issue of *Aperture* magazine; the magazine came out quarterly, and Minor White was its editor-in-chief. Fortunately, I had some sensitivity about such things as page layout.

Often he made portraits of me. These were very intense sessions, though he did try to put me at ease. There was confusion and resistance in me. Minor's questions often were challenging and confusing. These portraits evolved dramatically from one session to the next (over several months). They are exceptional portraits. For example: in one session, all these images made me look like I was no more than nineteen years old. I

was thirty-five at the time, so you can imagine my shock. I still have these portraits and appreciate them even more today. Something in me evolved over those several months. I had begun to understand what my work was, and my photography became more focused. In a word, I had found my *direction*.

One weekend he was working with a new sequence of images. They were spread out all over the floor, and he asked me what I thought of them. At that time I scrawled my impressions on a piece of paper and shared these impressions with him. I told him I would make a clean copy and send it to him later from home.

———

Minor White's sequence—The Sound of One Hand Clapping

When I saw this sequence, the third image was of two very beautiful flowers. They were an unpublished set of images, incomplete as yet. The flower image was replaced by another image in the published version. The other images are the same as they appear in *Mirrors Messages Manifestations,* published by *Aperture.* I took notes when looking at the sequence and later sent a note to Minor White, with my corrected responses that appear below. He sent them back to me with the word "Blessings" scrawled in black felt pen across the page. I felt this action to be an example of creative response—an exchange between two thoughtful people. Each number represents an image in the order in which I saw *The Sound of One Hand Clapping*. To me it's a bit like a poem, and that also is reason for including it, because till then I had never written a poem (except in high school).

1. *An empty bowl—pail—receptacle sits with the faintest impression of promise.*

2. *Now love reveals herself in pure light and air. It gives meaning and promise to purpose.*

3. *There! Like magic, two buds burst forth full-blown within the circle.*

4. *Somewhere in the mind, in the body, and in the spirit of things the seed grabs, holds, takes root and grows.*

5. *It swirls in growth like a universe spinning new worlds. Yes. The seed has purpose.*

6. *It grows into a form of definite shape, like a "you" or a "me"!*

7. *It is special in its being, for the sun does not forget it.*

8. *Nor does our soil forget any more than we do; she waits, pure in her expectation.*

9. *A new harvest—again harvest, and the bounty itself pays homage to the glow of moon and fields, and perhaps a star.*

10. *We rise again, growing from more than promise. From here again, and . . . again . . .*

———

So what is the sound of only one hand clapping? Is it just another Zen koan, like getting the chicken out of the bottle? One Zen student said, "The same way you got her in there." Perhaps a simple hand clap releases the chicken. At times everything seems metaphoric. When I ponder all the possibilities, I'm not certain. Explanations often don't help. I will say, however, that what is important is what you bring to the question, and you can only bring yourself.

Working with Minor in Utah, 1963

On a chilly morning, while we were having breakfast at Capitol Reef, Utah, Minor asked, "Would you like to explore another place?" Of course I was very willing.

Behind his question was the fact that he was interested in returning to a spot called Chimney Rock. Minor and I took off in the microbus. It was a wonderful morning; the sun just rising, and with each turn in the road we were either in shadow or blinding light. Staccato rhythms played back and forth, though never monotonous. As we pressed on we talked, and I puffed my pipe. The window was open to clear the air, as Minor did not smoke. A twisting roadway, and finally Minor pointed to an outcrop of rock high above the road that was to be our destination. We continued on a short distance, found the turnout to Chimney Rock, and parked.

We climbed a hill for a mile or so—very steep, and barren. On this slope lay beautiful stones—jasper and petrified wood everywhere—and as we trudged I was collecting these findings and putting them in my camera bag. There was a beautiful petrified tree branch on the ground. It seemed to be caught in an envelope of time, as though the tree had lost its branch, which in crashing to the ground broke into many segments. I realize this is not what happened—poetry gets the best of me, and so I put it like this. Reaching down, I pulled out one segment to investigate, and slipped it into my pocket—a special prize. Minor continued on, so I hurried to catch up; we continued climbing together.

On up the hill I saw another even more beautiful piece of petrified wood! By now all became too much to carry, along with my 4 X 5 camera and the rest of my gear. So I

turned and threw away the earlier tree segment. Minor stopped and asked, "Why leave a mess?" His comment struck me, so I walked some distance to where I'd thrown the piece, and continued down the hill to replace this segment, exactly in its original place. I returned to where Minor was waiting, and we continued up the hill. Nothing further was said. The incident was dropped, but I felt uneasy.

We reached the summit where two canyons met, one lying straight ahead and another to the left. I was feeling a little uncomfortable with Minor at that point and decided to explore the canyon to the left. We parted company. Minor continued hiking straight ahead.

Suddenly alone, it seemed to me as though no human had ever been where I now found myself. These walls hundreds of feet high surrounded me and went jaggedly upwards. The wonder of the place was overwhelming. I was finding it difficult to cope with my situation of being there. There were shapes of skulls in the walls, all fine and very detailed—human shapes trapped, and transformed into stone. I even attempted to photograph some of them, making several exposures. Not being able to cope, I sat on a little bluff to quiet down. It was such a silence that I could hear even the slightest movement of air. There was an uneasy feeling in the pit of my stomach, and at the same time a sense of awe. My heart was audibly pounding. Though I wanted to continue I was afraid to do so. Frustrated, I turned away and walked out of the canyon with a sense of hostility deep in my bones. Discoveries were lost in that avalanche of emotion. To this day, I feel the loss from having passed up exploring Chimney Rock canyon. But what was gained is perhaps as great: a more healthy respect for the unknown, and a stronger realization of the strength of what it means to be ruled by identification and uncertainty. Anger—kept masked by fear—took its toll; this

deprived me of continuing my walk up the canyon to discover more images . . . inside and outside myself.

It isn't easy to find the healing qualities and the beauty of silence, nor to see that association with fear and its constrictions cut me off from the *seer* within. There is a stillness and silence that keeps returning. There is an odd feeling and questioning about sound or the lack of it, which has confused me since childhood. At different times it has had differing effects.

––––––

An experience of mine in Oregon very much relates

Twenty-five years later, I was walking and trying to find some relaxation in nature—from the trees, the space, anything other than just walking along for physical exercise. I was stumped. Then I remembered that nature does indeed give something to us; and that we in turn return something—an exchange of sorts. It was impossible to express this with my head chattering—this distraction which is not actually thinking. Then somehow I remembered to just let go in the face of impossibility, and I continued my walk. I looked up a few minutes later at a wonderful grouping of pine trees, and a green glow entered me. But that wasn't quite the whole story; there was also the silence. The trees were silent with a presence about them that connected with the *seer* within myself. At the moment of an impression like this I am connected with something other than my ordinary self. That silence was enormously nourishing, and in the moment I knew and I understood who I was—at that moment.

That same night, with a group of people, a similar thing happened, only this time it was deception. I remembered those trees, and then I remembered some rocks I had photographed in the ocean as the surf pounded them. This inner dialogue was talking with itself, and taking me away. In this case, these experiences were held together by one common thread—dreaming. I was dreaming about what I had experienced earlier and not being present with the people I was with.

It seems impossible to explain these oddities of silence, although they return often and open strange possibilities. To be here, in the presence of silence, is to understand it; after the experience it is not understood well at all. I expect nothing much of my ordinary state, but I do not give up. It's a thin line between these two experiences. We live in time, whereas that unique silence seems timeless. It is in this timeless state that images arrive. Even saying this much is a bit presumptuous on my part. All that's possible is to be grateful for what is found, and to keep one's eyes open.

————

T. S. Eliot, in Four Quartets*, writes haunting stanzas:*

> Time and the bell have buried the day
> The black cloud carries the sun away.
> Will the sunflower turn to us, will the clematis
> Stray down, bend to us; tendril and spray
> Clutch and cling?

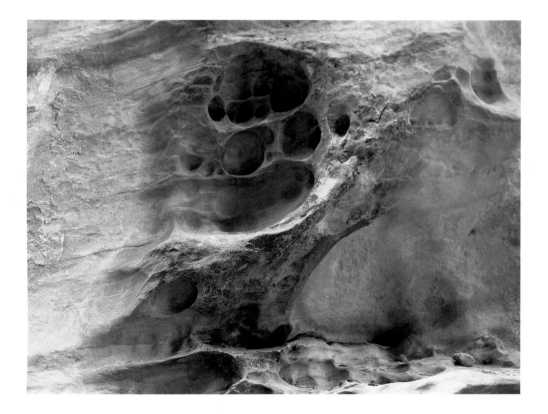

XVIII - Skull - Capitol Reef, Utah - 1960s

Chill
Fingers of yew be curled
Down on us? After the kingfisher's wing
Has answered light to light, and is silent, the light is still
At the still point of the turning world. [1]

———

There is always an element of resistance

During a ten-day workshop with Minor White there was a revolution among the students. To have some dissension at a workshop is not unusual. The reason the impression stayed with me so long was the manner of its unfolding:

Two students from Kansas could not see eye-to-eye with Minor as to how, and in what direction, the class was going. They could not see that the effort we were making helped them personally in their lives (they were teachers themselves). One of them was athletic, always occupied with dancing through the grasses, snapping pictures this and that way—relating every experience, and all assignments, to his dancing. Everything that was given to him he applied to his experience of physical movement. The other teacher was very cerebral and he had set ways of going about things. He was having a very difficult time getting beyond his personal predilections and did not comprehend, in his own mind, anything that was happening in the workshop. Nothing fit his already established methods. Both of them had an effect on a number of students in the workshop, and as a result it appeared we could not move another step unless this problem could be addressed.

Minor announced his own reasoning about the situation in the evening. He decided we would work in a different way the next day. The two teachers from Kansas were each to have some of the class to work with. They would work with their own groups, and even make their own assignments. At the end of the day we were all to gather and present our findings. His suggestion was acceptable and most everyone seemed invigorated by it and willing to work in this way.

Later that night I talked privately to Minor about my concerns about the whole thing: "Why did you let them take over the workshop? They came to study with you—certainly not so they could tell you what to do!" His answer to me was direct: "It is their workshop." And he went further: "To be a workshop it needs to include all of us." Then he said not to worry and that he needed me to play a part, since someone would have to help with the younger students and keep up their interest. "You need to work with them and find a direction together." It could even be along the lines we had been working in; we were free to choose.

The next morning the groups were finalized. For myself, I gave the groups names: the nature group, the idea group, and the youngest group.

The young people met on a little hill outside the school lounge. We searched for a way to continue our work. This made it necessary to see what we were interested in together, while including what we had been doing till now. Many people talked about what they wished for, though they were unsure about it. They wanted to continue exploring the question of mystery, which in a way was what we had been working with without saying it. All their comments led me to formulate an assignment that I hoped would be acceptable. I explained that being here working together was like landing on a strange

planet, and I wondered if this could be the assignment. Each of us, in his or her way, could photograph this new planet, but not one of us could do it alone. Together we could collect images and make them into a sequence to crystallize what was found. This sequence could then be presented at the end of the day.

We decided on a small area to photograph that would be our planet, which would keep us in close contact. The rose garden, enclosed by hedges, was perfect. Even so, it was quite a large garden, and at its center was an inviting fountain. We all sat around this fountain, beginning with a moment of silence. To be quiet in such a situation seemed important and useful. We even decided to be silent as we worked. The work went forward without further comment, with each working in his or her own way. Quietly people would show each other their findings as they received them from their cameras, without speaking. The session passed in this way, filled with our quiet and the focused intent that can come with such an effort.

All three groups worked separately. The idea group worked with images found in the chapel. The nature group, much interested in movement of the physical body, went into the woods to photograph. What took place in these groups as they worked I'm not certain. We would see what they found when the groups presented their work at our gathering with Minor.

The other groups presented first; they each pinned their images on the long board in the auditorium in turn. The rose garden group was to be last. The first two groups' presentations were prescribed in a formal ceremonial sense. I remember the strong content of the photographs shown. The nature group danced around the hall to give reinforcement to what they were trying to express. The dance supported the image,

and the images supported dance. On the other hand, the idea group spoke of symbols and meanings of symbols that gave strength to what they had done. Each group presented in its own individual way.

We in the rose garden group were taken aback, feeling less and less up to our own presentation. We were impressed by the others' work and were at a loss as to how to show the material from the rose garden. I personally felt that I had led the group down a primrose path. This was a dusty road at best, and in the moment we were stuck as to how to find a way of showing our pictures, to set the stage.

We asked for a recess before going on, as our group wanted to meet once more in the garden. In the garden we sat around the fountain, with feet dangling in the water, again. Here an idea emerged that we ought to present our photographs in a simple, quiet way, as we had found them. To do otherwise would somehow betray our experience of collective work together. The die was cast, and so we agreed.

Our sequence was pinned up on the long board. We kept absolutely silent. We had decided not to speak and that eye contact would keep us in touch with each other. No words were presented to the audience, only the photographs. No explanations were given, only smiles. Our audience didn't know what to make of it. Finally, one of them went up to the board and began looking at the images closely. Then another person went, and then another, forming a long line. They looked quietly at the images as they moved in front of them. Just like going to the movies on Saturdays, waiting in the ticket line, they each waited their turn. It was wonderful. It was funny. It took time for everyone to get past the images, and once they did they nodded approval quietly as they each sat down. There was no discussion, nor was any needed. Transmission took place.

I cannot say that the students saw what took place for certain, whether or not they could see themselves in these events. They were satisfied in going their own way that evening, and by the next day we returned to our usual procedure, with Minor bringing a direction for the day. If we could truly see ourselves better, this alone would bring change—and practical exchange.

————

Another quote from Four Quartets, *by T. S. Eliot:*

> Time past and time future
> Allow but a little consciousness.
> To be conscious is not to be in time
> But only in time can the moment in the rose-garden,
> The moment in the arbor where the rain beat,
> The moment in the draughty church at smokefall
> Be remembered; involved with past and future.
> Only through time time is conquered.[2]

. . . In this there is an echo of my own past experiencing.

————

Struggle finds a way—the enemy is within

Over the years Minor and I had our disagreements; I sent this note to him in my early years:

What I need, see and find for myself is that all roads lead to heaven and each of us potentially has his or her own path. The stones, roots, ruts, and streams that lie along this path are work on a general level. Others can point out the common direction we go in; this is in the nature of all things. My path has many stones, many obstacles. They are mine to see or to trip over in order to learn. No person can point out these obstacles, because they lie within us. They need to be found.

This response came from me because I saw that the teacher was actually within, and even though Minor didn't act like a teacher I wanted to make sure that he understood that I had reached this understanding. I'm sure he valued this indication that I was finally growing up. I was finding a direction in my search, with help from my study of Gurdjieff's ideas and my photography. It was Minor's suggestion that brought me to the Gurdjieff Work in the first place, and photography was what brought me to him.

Part of my attraction to Gurdjieff's ideas was seeing that Mr. Gurdjieff had an intense interest in craft and its usefulness in self-study. It is interesting that Mr. Gurdjieff had three specific crafts he was particularly interested in. The three crafts were music, gymnastics, and writing. Each had a different point of entry into ourselves—the feelings, sensations, and thought, respectively. At the same time, each was used as a stepping-stone to open to the other two. They became the means of opening us to the whole and finding balance in ourselves. I marvel at one of the questions I heard while studying his ideas: What is the place of craft in our Work?

———

In Joy of Man's Desiring, *Jean Giono wrote:*

He (La Jourdane) turned his back on the forest. And then life, life, life. Not unhappy, not happy, life, sometimes he would say to himself . . . But immediately, at that moment, he saw the plateau, and the sky lying over all, and far off, yonder through the trees, the blue breathing of deep valleys, and beyond, all around, he imagined the world wheeling like a peacock, with its sea, its streams, its rivers, and its mountains. And then he came to his consoling thought which said to him: Health, peace, La Jourdane, nothing to harm, nor to the right nor to the left any desire. He stopped, for he could no longer say: No desire. Desire is a fire; and peace, health, and all were consumed in this fire, and only the fire remained. Men, in truth, were not made to fatten at the trough, but to grow lean on the highways, to pass among trees and more trees, without ever seeing the same ones twice; to go forward through curiosity, to know.

That's it, to know.

Sometimes he would look at himself in the glass. He saw himself with his reddish beard, his freckled forehead, his hair grown nearly white, his big, thick nose and he would say to himself. "At your age!"

But desire is desire.[3]

I also believe it is so, "*La Jourdane,*" and in between is found liberation, through seeing.

———

My greatest resistance to creativity may be my overwhelming need for revolt against what *is*. Ignorance has its way with me most often, and I fail to question as deeply as I might. When I do question intently, there is intelligence and creativity there to help. Every generation has its revolution, and it may be very necessary that this be so. Need it be stupid, though? Hopefully it need not be, at least not for oneself. My own revolution began automatically in the fifties and I don't know if it has ever ended, nor did it properly begin, for that matter. There was so much to learn and understand, and life seemed short. What I do now can be more intentional. There is need for revolt, but it needs to be nonviolent and intelligent for it to be worthwhile. I wonder how to make myself clear on this issue. It is what I have attempted most, with some, though limited, success.

My opinion amounts to very little when what I tell myself I "know" has not been learned through self-study and a study of the nature of things as they actually are. It seems that ignorance can also be a resistance to creative impulse. When we become angry, there is very little intelligence available; and thus the very things we dislike and rail against defeat us. My battle is with ignorance; all my investigations seem connected with finding worth and truth in the world. Ignorance is indelibly implanted through our ordinary education. It takes time to discover ignorance and to accept the truth that it is one's own. It does not mean I need to be a conformist or a nonconformist in the attempt to work this out. Something shifts, and some gems are found.

———

The teacher we seek is within

The teachers we choose are important, yet they can seem limiting; there always is some resistance to them. What we resist most of all is the truth about ourselves. That is what is revealed through our guides, by even being around them. There is a need to have guides near, as they can help us find our inner teacher. Guidance in learning how to become quiet and listen to that teacher is crucial. Within me lies a whole world of potential; at the same time there are dangers. We cannot know what to look for in advance. Luck plays an important role in the search for a teacher. To see myself helps; to have this seeing along with a guide is necessary, as this provides an additional level of objectivity. The great prize is to be liberated from my ignorance. That comes through a struggle with resistance. It does not just happen accidentally. It requires some expenditure of energy on my part—some openness toward seeking truth.

The whole sense that the material world creates an alternate world of shadow has always fascinated me. We do all cast shadows. It seems a luxury to indulge in this kind of speculation, yet it is useful. There are images that connect the second dimension with the third, and the third with the fourth, and so forth. They unwittingly have the potential of casting shadows. They bring about psychological influences in me.

Today photography has become accessible to most people. Because of this accessibility, a certain respect for the media has faltered, and questioning of what the media can make accessible has also been weakened. Familiarity breeds complacency and leads to misunderstandings. Drawing with light has consequences that are magical and at times life changing. It has an effect, seen or unseen, and if we try to see, we'll be much less likely to be led astray. Photography can be a tool that leads me to the *seer*, or teacher within.

Sometimes stopping to think can cast a shadow and create a new perspective. This shadow/influence can be found in the realm of ideas in general; especially those that bring me into question. To think of *image as metaphor* can be revolutionary. Of course, these new concepts and influences are useful for me only when I come to them with some measure of understanding. The metaphor brought forth by one's understanding is quite different from the metaphor offered by knowledge alone. Understanding includes feeling and the actual experiencing of things, not just mental associations.

Endnotes, Chapter VIII.

1. T. S. Eliot, *Four Quartets* (New York: Harcourt Brace Jovanovich, 1971), 18.

2. Eliot, 16.

3. Jean Giono, *Joy of Man's Desiring*, trans. Katherine Allen Clarke (San Francisco: North Point Press, 1980), 6.

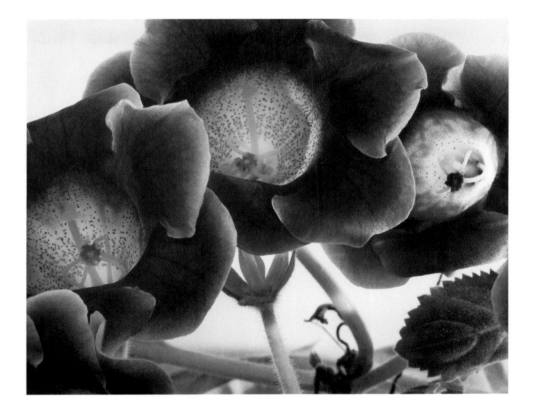

XIX - Black Flowers - Cleveland, Ohio - 1970s

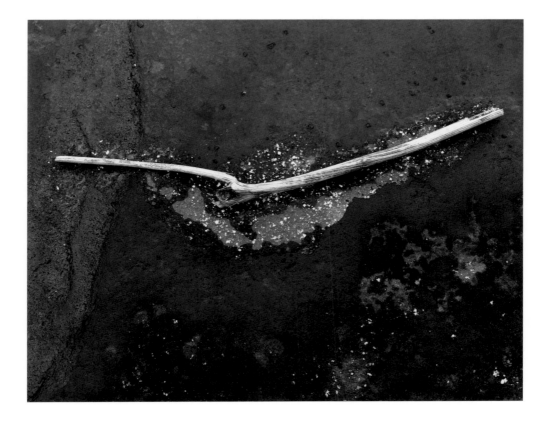

XX - Eternity (the light of "I am") - 1967

Chapter IX

THEATER OF THE ABSURD

Silence gentle abides within, a soft breath.
It is from that I awoke unknowing.[1]

That which has brought me to this point in my life and in photography can be expressed as frustration. Yet frustration and resistance are not all that have helped me search, and much interferes—especially all my work habits and general habits of thought. At times everything gets upside down and inside out. In the interim, I gather impressions . . . A lost place before time chases me, disturbing my sleep. And at times it plays jokes on me to wake me up.

———

I am reminded of a comment in *The Awakening of Intelligence,* by J. Krishnamurti:

> So the human mind must find the answer. It can only do that when it has understood the nature of thinking and has seen its capacity and has found a state of the immeasurable in which thought does not function at all. This is what is called meditation.

. . .

> Obviously there must be a different kind of meditation, a different kind of perception, that is seeing and not evaluating. To see the operations of thought, all its inward and outward movement without giving it any direction or forcing it in any way, just to observe it completely without any choice, that is a different kind of perception . . . If I can see myself as I am without condemnation or saying "I'll keep this and I'll reject that," then perception has a different quality. Then it becomes a living thing, not the repetitive pattern of the past.[2]

Edward Weston once said, a means of expression always lags behind one's ability to say it. I am paraphrasing in this instance, but this is quite accurate. It stands to reason that the desire for expression comes first and then the means follows. All our learning of words and methods leads often to forgetting our purpose, and quite often what we do turns into an imitative work—not valuing my own brains, or recognizing the spirit behind the forms. A study of words and methods can quite often lead to dumb noise and empty expression in the hands of the unsuspecting craftsman.

In the name of preserving expression, let us put into question even pre-visualization and post-visualization. When I was a young photographer it was suggested that at the time of photographing I pre-visualize the finished print. When I got too caught up in techniques and method, the moment of experiencing what was before me was lost. For me this brings anticipation, and with this my seeing is blocked. It is difficult for me to resolve this problem with myself. It seems that pre-visualization needs to become an instinctive tool, kept in my back pocket in case of need but kept at arm's length as I work. This may be a limitation on my part, but I feel I must mention this difficulty because many people become mesmerized by the method of pre-visualizing. Caught up with thoughts of a finished product, we forget the theater in front of us. Often dead butterflies are taken home and pinned to the wall—to no purpose other than to be "pretty." In this way the experience of theater is lost. At the same time, there is a need to put trust in the photographer within to know his business, to make a negative. Each thing must take its proper place, and the play must proceed.

In addition to this trap of *doing,* there is *imagination,* which can sweep me away to such an extreme that at times I wonder what is meant by creative imagination. I am drawn into dreams of fulfillment or frustration by imagination. There are pitfalls everywhere. I am caught so easily, and I cannot be certain where a special impression may come from. Most often they do come unexpectedly. I make a point of being here now—looking—feeling for the essential.

Results come through preparation, and at times I simply do not know how to prepare; I am not ready for what is. What's needed in the field is equally of use in darkroom work.

There is a hunger for new impressions, and a need to be with that movement. The negative in the darkroom, as I make the print, is wondrous. It is not the image experienced in the field, nor do I try to make it such; this approach allows the negative to speak. How could this be? The negative is related in kind, but it is a separate entity, also original. There need not be striving to make it otherwise. It is the impression of the moment unfettered. In this we can experiment with a not-knowing state of mind, finding the negative as though it were a stranger's negative. We can savor this fresh feeling. The image becomes a by-product, and the experiencing of it needs to be alive and loving. We fall too easily into the past or the future and in doing so we lose the chance to discover the freedom of the present—of being in the present theater of action.

In the end, this is the way of it: first I am touched, and then stretched for the means of expression. The question is: How to be? I need to share my responses with others, but above all else there is the experience first, and then a technique, which in my case I've learned through *camera work*, and sometimes in poetry and writing as well. A point of view held by the heart should not be dissected too much by the mind. First the mind and body need to function as equals, and then a finer quality of experience (a finer quality of emotion) will be attracted.

———

Dawn of Being—1981

In early morning air
The herald is heard.
Lying here awake
Sensing one being . . .

. . . Dawn

. . . Bird

. . . Room— this bed and my body.

In this moment I am not yet habit—I simply am—
Then thoughts swirl over me like a huge wave.
My landscape is drenched beneath cascading surf,
And all that is left is naught but foam.

Think . . .
Who can hold back an ocean?
How to remain "am" instead of it?[3]

———

A way of harvesting

The eye is usually attracted by basic preferences that take charge and prevent us from being available to the situation. In such a way, our images stay pretty much as they have always been, repeating the same core-form icons, which do not evolve or develop. So we engage in the same things over and over again, with little variation. In seeing this, can there be an opportunity of discovering another nature from which creative impulse comes? Not by changing what we see, but rather by observing what is seen—unattached to the movement of what we see—and through that action we will find expansion. The problem is that we seldom notice what's going on and keep repeating a few familiar patterns; there is a constant need to be aware of this.

With a right posture, water flows over me and through me; I am like the rocks along the shore, which are shaped through relationship. There can be an intention, but when I try through violence and pushing there are unpredictable, and perhaps negative, results. How to intentionally be open seems a great problem.

What is the right moment of exposure? In looking with this question in mind, I can watch the light change and see the image as well. A breeze moves a twig in the landscape; the water moves the soil and in the process is itself changed, creating new patterns. So what is the right impression? Without this movement and the energy of attention this process brings me, I cannot actually make up my mind. So I watch and look, simply drinking in this impression that has taken twelve billion years to reach me. I keep moving. Sometimes there is a moment "in between" that shimmers, and the shutter releases; *there*; there is no thought, just *image* accompanied by a faint glow of feeling and me here now.

———

Gifts flow from wondrous places

On the ground are seeds within their shells, revealed to me only through being back-lit by the sun. The walls of the cliff glisten—rocks, water, and sand are all so innocent. All of these hold within them seeds that can spring into creative action at any moment. Those faces mock me as I sleepwalk among them in the streambed. When I am awake, we laugh together. A world of feeling that was deeply asleep, and bottled within, can be aroused. This helps in the gathering of *image*. Image? . . . even stone can become a flower with this feeling. Does this allow the flow to enter me, an image that runs

parallel—creating an inner resonance that feeds growth? This feeling can develop and becomes a new sound that expands.

The water constantly speaks to the stones, sand, and little twigs; all things are changed through conversations with each other. I try to record those conversations, and the subtle changes that take place through them. In trying I am transformed, and we speak to one another. I walk upon the mud and my print is made, responding with "yes." Water cools my feet and speaks to me. The moon setting in the morning is glorious and not at all out of place in the full morning light. The sun sweeps the bend of a cliff, and the cliff responds, splattering sunlight with shouts of glee, and my tears well up.

———

Windows in time—1983

"There is a place in Cleveland where I can have a croissant and coffee of a Saturday morning. This is what I am doing just now. I like sitting here writing and looking out the window from time to time . . ."

This is as far as I got with a letter, then someone stopped to talk with me. In Boston it is better because there I can be anonymous. In any event, here I am in Cleveland again, in the coffee shop with my notebook, and it's the day before Christmas. It's warm and seems like Easter. Thoughts of Minor White waft in and out of my mind. The sound system is playing a Mass by someone from the Middle Ages, and a vision of Minor's hallway at Arlington Street appears. The sound ascending up to the meditation room at the very top of the house fills my senses. My heart fills with tears. Again,

feeling overcomes me. What more can be said than to say I need to learn how to contain my feeling—not to give in to ordinary feelings so completely, but to study them.

Minor lived in a large, hauntingly massive house in Arlington, Massachusetts. I was amazed that he should have bought such a large house. Being a single person one would wonder, but he always had people, and students who lived-in. I remember when I first saw the house. I felt I was approaching some great novel of the eighteenth century with too many pages in it. It was elegant, though he had very little furniture that matched the look, other than the few pieces of Victorian furniture from his mother. So it was haphazard at best, yet was grand at the very same time. It was a house to be loved, and Minor certainly loved it.

It had a grand staircase that rose to the second floor, which seemed to me to be at least eighteen feet above, although I don't know if houses have ceilings that high. This old house felt as though it did. From the second floor you could climb a second set of stairs to the attic, which was used as a meditation room. As you ascended this last stairwell you could smell the aroma of incense. In the morning this room could completely fill with sunlight—I thought it a most perfect place to meditate. It was here I found two special images. One was published in *Aperture*, and the other you can see here in this book.

We meditated each morning before breakfast in this room. I had asked Minor if it was all right to photograph the meditation room, as it seemed so sacred a place.

He said he didn't mind. That morning after breakfast I returned with camera and my stuff—to photograph. When I entered the room this second time, it seemed like a

church, a sanctuary with sun streaming through the window. I heard Gregorian chants softly coming from the interior of the house—Minor had turned on the "high fidelity system." Included in my impressions were sitting pillows, straw mats, a bell, a bowl, and the smell of incense—all contained in the moment, and the moment depended on my inner silence. Sight and sound seemed to blend into an entirely new dimension, and here I was with primitive instruments trying to measure it. The mats floated above the floor and the pillows in turn did the same. The bowl with its hand clapper seemed poised to make sound. The experience of meditating earlier that morning returned. I made the exposure, then turned the camera one hundred and eighty degrees and photographed the window as well. I knew then that I had finished, but lingered for some time absorbing the quality and feeling all around me.

––––––

Observations from the same coffee shop

Outside the window, a child is hanging on, dragging along behind his mother. Fall rain swishing, pulling my thought along. On dull days, the inner light can be a bit more present. What a wonderful blending of the present and the past in me then. The child suddenly breaks away from his mother. Surprised, she races after him. Then, within hand-touch, she and he burst into laughter. We are one in such an experiencing.

A young lady pouts to her boyfriend here inside the coffee shop and complains of his lack of understanding. Through tears, she half-smiles as the adventure takes place outside the window. Tears are always so close to joy, bittersweet—joy and sorrow. Ah, the human condition. Outside, a rotund lady sits sideways on a bench. She holds several

boxes on her shoulder, and her head is hidden. Precarious, delicate balance, round body—and boxes create a square head. Rising smoke from the square makes the image complete. From nowhere, from behind the boxes, comes a hand with a cigarette in it. Meanwhile, our young lady in the shop has laid her head on the table and quietly sobs. Without the least bit of apparent embarrassment, the young man waits for her to stop.

We have a hunger to influence each other, that others not be indifferent toward us. We are all pale shadows passing, yet not passing, or at least not truly alive in this passing. And so I sit here staying close to my inner tears that drag me into forgetfulness.

––––––––

Venus is so bright this morning. It was not me who noticed—it was my wife Jean. It did not make the joy of it any the less that she brought my attention to it, that I didn't see it first. There is a statement some people have made—"The soul is the invention of ego." It gives rise to doubt, and irritates me. Would it give comfort to the ego to invent such a thing as a soul? No one who understands the nature of *soul* and *ego* could believe that.

There was a great program on television last night about the shamanic religion, which is one of the oldest of religious practices. In the program they spoke of the flight within, the return to "essence," to the "soul," the basis of man's being—in a word, meditation. It was quite moving. The point for me was that the shamans, druids, ancient Mexicans, and the early Egyptians always returned again and again to the idea of the *soul*—making these flights into the very essence of the self. The soul is not the invention of the ego. This is clear to me whenever I return again to this source. Each return

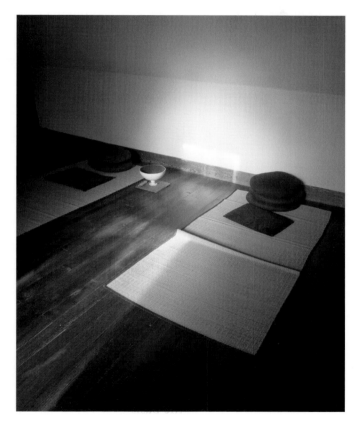

XXI - *Meditation Room #2 - Boston - 1975*

is a blow to the ego, because in my turning to the soul for refuge the ego's advice is refused. It is a goal, an aim, and a wish that I often make space for in my life—as the power of ego is so strong.

With all this comes a question. How can I present my work in such a way as not to be an obstacle to others' finding their way? It does seem to be more about my getting out of the way than teaching anyone anything. Of course, I have to have found the truth to get out of the way. This is why I like the word *keeper* better than *teacher*. Even right action can incur the wrath of the gods; only they are allowed this privilege. For interfering with the inner workings of others, we can be hated by our fellow travelers. There is indeed "something" quite separate inside us that can speak up and be counted, but I cannot tell anyone this. It is most difficult to continue, but I find it necessary to offer up this small book in the hope that others may be assisted in finding their own way.

This chapter is called "Theater of the Absurd," and as I read over the material I really wonder if I have drifted a little too far—but no; I have included these journals to fill out the image. These are experiences to which I have responded; they either feed or do not. There has often been a question awakened for me when I've read about photographers. But what do they like? What else are they interested in? For example, there are very few pictures of people in my work. I feel sure there is the question, So why? In fact, many have asked me point blank. So I have inserted a few observations about people in this chapter, and there are some photographs in the book—of people. And it may be that I am simply a coward and am attracted to flowers, rocks, and trees because they don't bite.

———

On the other hand

I had a very interesting exchange with the carpenter working on the addition to our house. We spoke of the idea that others are always at fault in everyone's view, and that this is practically a universal law. We were laughing quite a bit about the state of affairs when my carpenter friend remembered a ditty that he had learned as a child in the fields of Oregon, while harvesting beans. He said that someone, he didn't know who, a few rows over, began chanting, and after it was repeated several times they all knew it and began chanting together as they worked. The ditty was so to the point that he recited it to me, and I asked him if he would repeat it so I might write it down. We bantered back and forth about this, and I tried everything to cajole him into repeating it, with very little success:

> "Could or would you write it out for me?"
> "No, I don't think I could do that."
> "Maybe your wife could write it out."
> "Well, I don't know."

On and on we went, bantering back and forth, and finally I said, "When you need to take a break come into the house and stop by my computer room, where I have a recorder; there you might recite it again." Recorders were out. So the next day he brought in a copy printed out in his own beautiful hand-script.

———

The ditty:

> One bright morning in the middle of the night
> Two dead boys arose to fight.
> Back to back they faced each other,
> Drew their swords and shot each other.
> The deaf policeman after hearing the noise,
> Rushed to the scene and killed
> The two dead boys.
>
> If you don't believe this story is true
> Ask the blind man around the corner—he saw it too.
> The old blind lady, after reading the news,
> Threw down the paper and blew a fuse!

All of life may be a theater of the absurd, and from that theater I can learn—and at times I blush at my ignorance. This is certainly a strange conversation I have gotten into. The aspect that seems to be most honest in my experience is that I see all external things in me, rather than seeing me in all those things. I do not see myself very well, but see the possibility of a symbiotic relationship where we swim in the greater glory of it all. In addition, we are equally done and undone by the same stuff. What is there to do other than find a way to accept?

Endnotes, Chapter IX.

1. Nicholas Hlobeczy (unpublished).

2. J. Krishnamurti, *The Awakening of Intelligence* (New York: Harper & Row, 1973), 464.

3. Nicholas Hlobeczy (unpublished).

A Theater of Magic

Freedom or slavery

It is midnight, a perfect razor's edge, the altar upon which is placed the old—and in a twinkling of the eye appears the new. This is a moment of magic. I do not think there is any more perfect title than "Midnight in the Garden of Good and Evil"; it is an incredible metaphor filled with enchantment—a moment when all is poised. Within this garden we are fated to live, or, in a moment, to die. It can only be seen from off-stage, outside time. How to go on? That question never disappears—but we do go on.

In another era it was said that there are white magicians and black magicians. The truth is not in magicians being black or white, but in the magic within. There is value and purpose in understanding both. There is magic that has promise, which frees us and opens perception—and another that enslaves, while making false promises based

on illusions. They can be found in photography, as in all things, dogging us at every turn. Struck by this, we are compelled to verify—and conferring with others about it helps. This can make us a part of the human circle. Working with others is useful; through exchange our deceptions become transparent. The *creative audience* experience is useful in exposing such truths, but even this can be deceptive and turn into the ravings of black magic, as all depends on the purpose for which we come together.

As to purpose, *creative audience* is one of many ways to break the cycle of habit. In my classes we try to take the time to look at photographs and choose our words rather than rely on self-deceptive games. The class is an experiment in attention, which in fact is the price needed to be paid to free us from false notions. Out of these classes can arise a new language based on sincerity with others and myself; it brings with it a new sense of truth.

There are automatic perceptions that are restrictive, creating illusions; addiction to automatic perception destroys any possibility of inner freedom. My own mechanical perceptions lead me up box canyons or down primrose paths of self-deception. The purpose of that particular circle of perception is to support a dark side of us, feeding selfish ends and causing us to lose ourselves in endless repetition. Those who reside in that camp tell lies, deceiving themselves first and others eventually. In this there is little need for attention or conscience; it is filled with many forms of mutual flattery and self-deceit. We see ourselves as giants in this imagining. It is certainly sad.

———

In *The Powers of the Word*, René Daumal deals with good and evil as he finds it in the poet; however, I feel that it can be applied even to everyday life. It must be addressed if we are to find any freedom at all from illusion:

> Black poetry is fertile in wonders like dreams and opium. The black poet tastes every pleasure, adorns himself in every ornament, and exercises every power in his imagination. The white poet prefers reality, even paltry reality, to these rich lies. His work is an incessant struggle against pride, imagination and laziness. Accepting his gift, even if he suffers from it and suffers from the suffering, he seeks to make it serve ends greater than his selfish desires: the as-yet-unknown cause of his gift.

And in the following paragraph it is obvious that he is speaking of insight and self-deception and how the question can become blurred if I don't keep an eye open.

> But if I was once a poet, I wish to be a white one. In fact, all human poetry is a mixture of white and black; but some tend toward whiteness, the other blackness.[1]

———

On a new language

There is a need to speak about creating a new language, of finding one's own way rather than mouthing current habitual phrases as though they were understood. I need to hear my own voice, but for communication, the listener needs to be awake as well.

Thoughts, feeling, and body—each goes its own way and as a result all can be confusing cacophony rather than music.

How can there be involvement of body and feeling when the messenger never arrives at these other places, which are also a part of me? Could words touch body and feeling—beyond go-right/go-left or like/dislike? Is there a way to experience words with more than the head functioning? The experience can be misinterpreted when I try, because conflict can be a result, or even laughter. The functioning of two parts of me at one time quite often is experienced as conflict, because there can be two different views. I tend to judge them. In judging I miss a very special moment.

How can study and change begin if every chance moment of awareness such as this comes under judgment and requirements—this ordinary knowledge of mine which I assume to be objective? Would it not be better if I lived "not knowing" for a moment?

It is not the right and the wrong of issues that matters, but right questioning. I need to create some vertical movement for myself. Circles need to become rising and descending spirals; otherwise, all is repetition. This is a metaphor for human development. There is a need for new perimeters and attitudes that grow through study—a seeing and a proving that can penetrate the fog of levity, complacency or violence. More of our selves need to be invited to participate.

My use of language needs to be purposely active, not just a way of passing time. There is a need to get out of the way of my own views if I am ever to find a more real language—a language that calls my parts to come together, rather than pulling them apart.

We all know the typical responses to works of art

"I like it." "How interesting." "That's nice." "Gee, how did you do that?" "I don't like it; it's not my thing." The list is endless. These are not the responses we are looking for. I'm sure we can find numerous innocuous comments among our peers; so let such comments be reminders of what is not useful. Can we discover ways to say what is nourishing for others and ourselves?

It is much more rewarding in my university class—for anyone—when we hear such responses as the following.

In looking at one of my images a student said:

> I am the rock.
> I am the stone.
> I am the sun which shines upon me.

This response opens up possibilities, and it shows how to approach photography as well—with begging bowl in hand—because we are beggars. It is a new world when looked at through the lens of what is rather than of mechanical know-how and judgment. To sense the subject as though it were myself leads the way to opening rather than closing. In responding rather than reacting, we are then able to move—to be more incisive.

———

My students often ask about resistance

Does body movement play a part in my resistance? In what ways do you and I move? In what way can I begin to know the way I speak, which is also a kind of movement? What resistance does talking bring, if any? Often talking and physical movement work in tandem quite mechanically. If I were a king or queen, how would I move and speak? There is always a cage, and within the cage my limited part in the action. There is a possibility of stepping outside that cage, but it is not for the faint of heart. Philosophically we can say "I am all people." In practice, however, we find ourselves entrapped in a narrow viewpoint, with rigid rules, and we follow these rules as best we're able. We are subject to the whims of the multitude, and through this limitation are fated to oblivion without recourse.

It is necessary to find ways of stepping out of our prison. Putting myself in someone else's shoes can be very useful. One of my first encounters with acting out a new role was in learning to print photographic images. It helps to have some guidance, someone to show me. It was Jasper Wood who helped me. His darkroom was a kitchen converted for that purpose—in a sense, quite ordinary, yet it was quite exciting. Jasper ran me through the process of exposure and development. I watched all his movements while he made a print, very fascinated, but then he said, "You try," and he left the room. I was left in the amber-lighted room alone, left to play a role other than stand aside as audience. Here before me was quite a combination of elements—the negative, photosensitive paper, white light, chemicals, and I. When the enlarger light was turned off there was no image. This of course is obvious, but a real shock comes when the paper is in the chemicals, changing, growing into an image. I was so taken with my first effort that it was as though the power emerged from me, not as the result of a

process. Moving from paper to the enlarger, and then to chemistry, in this darkened room delighted me. It seemed as if this were a divine manifestation within my own private ritual. I have these words about it now, but then there was the taste, and the wonder of a magic that liberates. This must be what white magic is, a transcending of ordinary humdrum experience. The shadow play is revisited, and change does take place.

———

From my notes at Lane's End

In the face of sorrow—magic was all around me:

It was the winter of '81 and my mother had just passed away the previous September. I was feeling profound unhappiness. Wondering what to do, I felt as though the source of my being had left. A need arose in me to go off alone, perhaps to mourn. I had never been off alone for any length of time; a taste of fear came with that need. I decided to take five days away from everyone in the face of my resistance and sorrow. It would be an experiment, a space and a time to do some work on our cottage that we called Lane's End; it was along the Allegheny River. There would be no neighbors around to distract me since it was winter and snow was all about us. In addition, I recorded a few of my thoughts while there; they began with fear and awkwardness.

At some point during those five days, a tune played on the radio, and, rising out of despondency, I became fascinated with it—sensing it. I felt life in myself hearing Judy Collins sing the song, "Killing Me Softly with His Song." The words I was particularly taken with were, "singing my life with his words." My spirit needs to be active to take

in such an impression from another person. I sense that the singer is aware only when I am aware, or I wake up to hearing. And yes, it is true singing from one spirit to another. A light suffused me and I saw the very air infected with life—and even with death. It was not just the time of year. At all times there is a life/death smell, and I simply noticed it more on that winter evening. It penetrated my body—it's in the bones even now—and for this I am strangely grateful. A moment of transcendence had visited me.

Events, when looked at as a musical scale, proceed as one note following another. There is a measured progression. Each day can have purpose. Later in the week it dawned on me that tomorrow would be the fifth day . . . sol, the day of the sun. It is a note in our scale. Some call it the sweet note—a place to take caution. The very thought makes me wonder. I had lost all track of time and could only think that time was vanishing.

———

Fifth Day

I had a very good sleep last night, slept through till just before daybreak. I got up, put wood on the fire, which had burned down to hot coals, and jumped back into bed.

Out the window I watched daybreak produce a landscape of trees; it was creating something out of nothing by the action of light. The world was being born again; somewhere around the world dawn is constantly creating substance from the void. Then later, how truly grand it was sitting at

my table writing. Out the patio doors I saw the earth just peeking out from under the snow. The trees and the shore of the river emerging from—or is it through?—the fog.

Beyond all this is a mountain waiting to come to life through the action of the sun. With the sun sounding its octave, the mountain will again be blessed. The river will continue to retreat toward its normal level; bits of ice and twigs no longer will be seen on its surface. They will just be a memory of past things and places. There is gratefulness to spirit for new images born through time and event. The branches of the trees, moving against the light and fog, create music with their very being. The river slides by, and I wonder at this silent landscape playing music. And with it comes more brightness; greater light emerges. Enough of this. Maybe it's enough to help me to remember myself. If only my ordinary existence could hold such interest. My tea water is hot, and I have yet to sit quietly.[2]

———

Later in the day I felt a strong need to leave this sanctuary—to return to the city and to everyday life with people. I have found a teaching in the world, hidden right in front of me. There is a great teaching and exchange in the air, innocent and quiet, and between people as well. Each time I am aware of this I am shocked. I have seen this often and attempt to make it a guide rather than being led by my common opinions. In this I find something to help me keep on living.

———

Lost principles

At the Cleveland Museum of Art there was an older woman, Margaret Marcus, who befriended me when I worked there. She worked for the Education Department and the Oriental Department as well. We very often would have tea together in the museum garden that was directly connected to the restaurant. And we would walk and talk together at times. She was attentive in an uncanny way, and I spoke with her quite often about the search for meaning in life. After one such conversation, which included ideas from the *I Ching* (The Book of Changes) and Lao Tse and even C. G. Jung, in whom she had a great interest, she said, "I have a wonderful book somewhere among my things about Taoism, with an introduction by Jung." I responded immediately, "I would very much like to read it."

About a week later she brought *The Secret of the Golden Flower* in to work and offered it to me; not only for me to read but she also said I could keep the book. She was cutting down her book collection, as she was about to retire. I was deeply moved by her gesture, and it made the bond between us even stronger. In our talking the previous day she had remembered a newer book by Jung that I could no doubt find, called *Memories, Dreams, Reflections*, recorded and edited by Aniela Jaffe, and so I not only had one book to read, but now, potentially, two. But for the moment what was important was the first book.

The book was what I was ready for. For one thing, it spoke about the circulation of light—the practice of moving attention around the body in sequence while at the same time engaging in whatever task was at hand. I worked with this exercise quite often while walking, eating, and even while reading. There is mystery and discovery in

this practice. I was able to connect with what I was doing, and it seemed to influence my general state of awareness. It certainly verified the idea that "it takes gold to make gold," as the alchemists insist. When I exercised my attention, more energy would arise, in the form of a more encompassing awareness.

A few months later—an evening in the fall—my wife Jean and I went to a concert at the Cleveland Museum to hear the Budapest String Quartet. I love chamber music, and they were to play Mozart, one of the divertimento, which are particular favorites of mine. While we were sitting in the hall waiting for the players to begin, I spied my curator friend in the audience and smiled inwardly because I remembered what I had recently been forgetting to practice—to be aware of sensation. They began to play, and I began to sense my body in cadence with the music—again and again it circulated around the body. It was a struggle to begin with, but I kept at it, as it was very interesting to experience the order that arose out of the music, which I had not understood as clearly before.

At the end of the performance, when walking out with the throngs of people, I experienced a grand sense of well-being. Listening to the people, the shuffling of feet and the laughing faces became the music. Outside, in the cool night, we were drawn to look up at the sky. Turning to Jean, I said, "Look! The night is filled with stars keeping time for us." There are gifts in life, and insights, but for the most part we are not here. Whatever magic there is, it seems there is a need for payment, and in the payment there is the joy of being.

———

The Sun was quietly rising,
And I could not understand
The wind, which blew it.[3]

I was bored this morning, but a look toward physical sensation brought with it a reminder of life. It was like tending and picking snow peas in a garden. It seems impossible to prepare for life, as it is to prepare for death. To what purpose would I do so? It is wonderful to see that all is surprise when we are here. It is difficult to comprehend what magic means, to understand, and the more we try, the more elusive understanding becomes. We speak of a thousand years as though it were nothing. Seeing this can bring a fear of our minuscule stature in the scheme of things. This enormity of numbers diminishes us. When comprehension and magic go beyond ordinary limits—allowing presence—everything seen is continually new and exciting!

———

Bright Spring – 4/10/05

Porcelain morning
Light—so hard and clean
All are delicate to the senses
Living glimmers through shimmers that glow.

Air busy with reds and orange dancing
Receptive altar—brisk in the moment.
Amid wishing is minuscule time
And tender shoots can grow.

A stop, a smile, and a wish
This moment sings
Forever! [4]

———

How can I speak in a more exact language?

The world of conscience and consciousness lies outside my time and there is no doubt they are buried in the subconscious. We are split off from them to create an illusion that we are one, and this illusion allows us to go through the motions of our lives in sleep. Illumination comes with consciousness; I know this as a fact only in the moment I wake. I cannot see my sleep—I can only know I have been asleep. What we are searching for is already present, but our grasping for it keeps it hidden—we are separated from our inheritance by fear, greed, and time itself. All our illusions are shifting expressions of time. It seems that if we are to experience eternity or *being*, it will take place here as we breathe, accepting sweet, bitter truths. When I am trapped in time I am trapped in fear—fear of life, and death, constantly fed with compromises and empty promises that continue the entrapment; even asking why can become a trap. Again and again we can come back to simple acknowledgment of being; it is what we are in our simple acceptance of what is, like children. We are not family, tribe,

group, nation, or cult; everything is included in *being*. This could be seen with the flowering of consciousness.

Silence is wondrous. It is the wellspring of all creation. It is behind all sound and movement, but we are hardly ever connected with it. To be connected involves the realization that we are locked in time, moving at incredible speeds through the universe. There can be no justification for not seeing this truth; in our sleep state we constantly claim ignorance as an excuse. The purpose of silence and the creative act is to bring us back to the infinite—to purify us. This has to do with the awakening of conscience. Conscience is part and parcel of silence, as is attention, and intention.

There are no rote methods for all; there are only paths. We do not make those paths, as they have been established from the beginning—before the big bang—like an afterthought of silence. And as Lord Pentland once said, "To my mind, the real legend is not about the journey to the top of the mountain; it is about the journey through the mountain."[5] All craft can help us to find our way, and for me photography serves that purpose. The arts in general can be a facilitator. One has to have a bit of luck, courage, and also a love for that which stands behind all manifestation in order to follow such a path. It is probably best kept secret, because I cannot give real knowledge away, nor the understanding gained from it. But there is also the joy of being an instrument of the infinite—again, the paradox—so we try. Because of this joy, man becomes an island of another nature, while at the same time, also paradoxically, he is also imbued with a sense of community.

Enough!

Endnotes, Chapter X.

1. Kathleen Ferrick Rosenblatt, *René Daumal: The Life and Work of a Mystic Guide* (Albany, NY: State University of New York Press, 1999), 174.

2. Nicholas Hlobeczy, notebook.

3. Hlobeczy (unpublished).

4. Hlobeczy (unpublished).

5. John Pentland, *Exchanges Within: Questions from Everyday Life Selected from Gurdjieff Group Meetings with John Pentland in California 1955-1984* (New York: Continuum, 1997), 205. Lord Pentland was responsible for the Gurdjieff Work in the United States from Gurdjieff's death in 1949 until his own in 1984.

AFTERWORD

In the moment—about digital work . . .

The present book will be left as is. There may be a need for me to write additional material concerning digital imagery eventually. The jury is still out on my digital work. Though I am no expert when it comes to technology, I do have useful things to say as a result of my own struggle to master the art of photography that others may find of interest. This twenty-first century has been an awakening. Technology truly has begun to speak in tones of awesome beauty and wonder. I see that my creative spirit loves it. She covets my time and thinks of ways to apply these new methods in the work to which she inspires me.

Techniques in the past have been so slow that they seemed at times to be more of an obstacle than a help. You may not know what I mean by help, because it is not the tricks and flashy aspects that interest me. Digital aspects of photography, however, do attract me; they bring time to the ever-present *now*—where all is ringing and singing. The muse is ready and waiting for such an opportunity of expression. Her concern is always to live in the present.

No matter how exciting it may be, we must be careful, because digital imagery is also a jealous mistress. It is important not to lose sight of the creative impulse in the excitement of this movement. It is so important that method not supplant meaning.

There is no resolution for me now; perhaps in the future I will show more and tell what I've found.

———

Originals of the photographs in this book are available through Wach Gallery: Peter M. Wach, 31860 Walker Road, Avon Lake, OH 44012.

———